MELTING AWAY

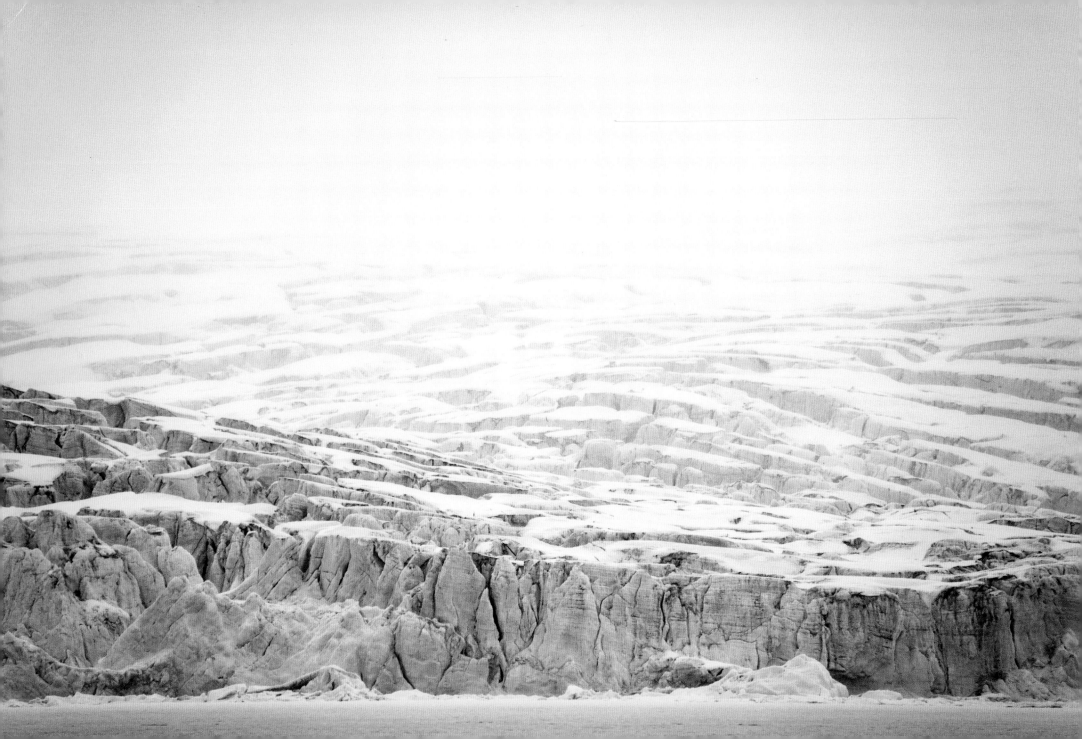

MELTING AWAY

A Ten-Year Journey through Our Endangered Polar Regions

Camille Seaman

———

Princeton Architectural Press · New York

To Tala, who gave me a reason to want to save the world.

Responding to
the Sensing Element

Elizabeth Sawin

In 1977 the astronaut Rusty Schweickart wrote a few hundred words in which he tried to convey to the rest of us earth-bound souls something of his experience of seeing our Earth, "that blue and white Christmas tree ornament," from space.

If I had the power, I'd translate his words into every language spoken on our planet today, and make them mandatory reading for every last one of the seven billion of us, until we all began to picture ourselves situated on "that small spot, that little blue and white thing…on that little spot out there that you can cover with your thumb."

When I first saw Camille Seaman's photographs, taken at both the far north and the far south of our little blue and white planet, I recognized in her a sort of kinship with Rusty Schweickart; a kinship best described in a phrase he coined. Camille, like Rusty, is a sensing element.

In his essay *No Frames, No Boundaries*, Rusty wrote "And you think about what you're experiencing and why. Do you deserve this? Have you earned this in some way? Are you separated out to be touched by God, to have some special experience that others cannot have? And you know the answer to that is no. There's nothing you've done that deserves this experience, that earned it. It's not a special thing just for you. And you know very well at that moment, for it comes through to you so powerfully, that you are the *sensing element* for all of humanity, you as an individual are experiencing this for everyone."

These sensing elements of ours go where most of us cannot go, will never go, and they bring back something for us, something that—if we let it—changes us. Suddenly we understand something we hadn't seen before.

Our home is beautiful. And small. And whole.

It's precious.

And it's changing.

We are changing it.

Experiencing this for us, capturing it in words or on film is really all that the sensing elements—the Rustys and the Camilles—can do for the rest of us.

They've launched themselves into space in a tiny rocket ship or trekked across the ice in the deadly cold. They've drawn upon their physical strength, their discipline, and their decades of skill to bring back for the rest of us a glimpse of who we are and where we find ourselves.

And, despite the power of a dominant worldview that insists that we are all separate, competitive occupants of a world that is not alive, they have been open enough to have seen wholeness and brought that sense of wholeness home to us.

From there, I'd say it's up to us. We've received the gift: the words, the images, the experience that was meant not for Rusty or Camille—and not just for us either—but for all of humanity. And we, as the members of humanity who happen to speak the language the words were written in or who can afford a beautiful book of photographs, or who were for whatever reason in the right

place at the right time to be touched by this experience, might ask ourselves: so now what?

What is to be done with this knowledge, this experience?

What should we do once we know that our world is so beautiful and so whole?

What should we do once wesee that our species—this species that is clever enough to fly into outer space to see the wholeness from which it came, this species that is curious enough to go to the most extreme conditions to see the changes it has wrought—is in fact in desperate peril?

There are, of course, as many answers to these questions as there are people to ask them. A general sense of possibility however, might come from my field of systems analysis, which would remind us that, on its own, a sensor doesn't change a system. Don't misunderstand: sensors are critical. But systems also need actuators. They need elements that respond to the incoming information and create change.

A thermostat (a sensor) may say the room is cold, but without a furnace, the room will not warm.

A speedometer (another kind of sensor) may say the car is speeding out of control, but without a foot on the brake, the situation can't be salvaged.

Our sensing elements—our Rusty's and Camille's—are the thermostats and the speedometers. What we do with what they've shown us, is up to us.

Camille—and her work—are unable to tell you what to do. The right steps depend on who you are, where you are, and the network of relations you are embedded within. Systems theory can't tell you either, not with explicit detail. But it can point in a few general directions.

1) Pass it on. The sensing elements are few and the need for actuators is large, so pass on what you have been given the opportunity to see. Literally. Share this book. Buy a copy for your father-in-law and a second for your public library. Lobby until it's on the list for your monthly book club. And, if you do such things, blog and tweet and post about it. Wire the world so that this particular sensor is connected to an ever-expanding array of people who will act.

2) Aim for the roots. What Camille witnessed at the poles is the end of a long chain of causation, tracing itself back to decisions to mine and burn fossil fuels, or even further back to the goals and choices of an industrial growth society. To change the future of the poles, and the future of our species, look for ways to influence those deep roots. Whether that's with your vote, solar panels on your roof, or a personal experiment with consuming less and enjoying more, take satisfaction in your understanding that, in an interconnected world, you don't have to travel to the poles to influence their fate.

3) Find your people. It can be hard to know that the world is whole, and imperiled, in a society that hasn't yet quite seen either of these truths. Don't let yourself be isolated and don't let yourself doubt what you have seen through Camille's eyes or through your own. When you share her work, and the work of others, when you take your steps to act at the roots, notice who responds, who steps forward to walk at your side. Ask for and give support. This journey of learning who we are and where we fit on the earth still has some distance ahead of it, and it is so much better, on a long journey, to walk with friends.

Camille Seaman first travelled to the Arctic in 1999. Between 2003 and 2011, she visited the Arctic and Antarctic on a yearly basis, ranging from one pole to the other as an expedition photographer aboard science vessels and commercial ships. The photographs and essays that follow are the result of this exploration of our increasingly fragile polar regions.

Somewhere Between the Sea and the Sky

Svalbard, July 2008

In Svalbard as I experienced this scene, I was perplexed by not just
the low hanging sky but also by the way the sky transformed the color
of the shore into a rich turquoise.

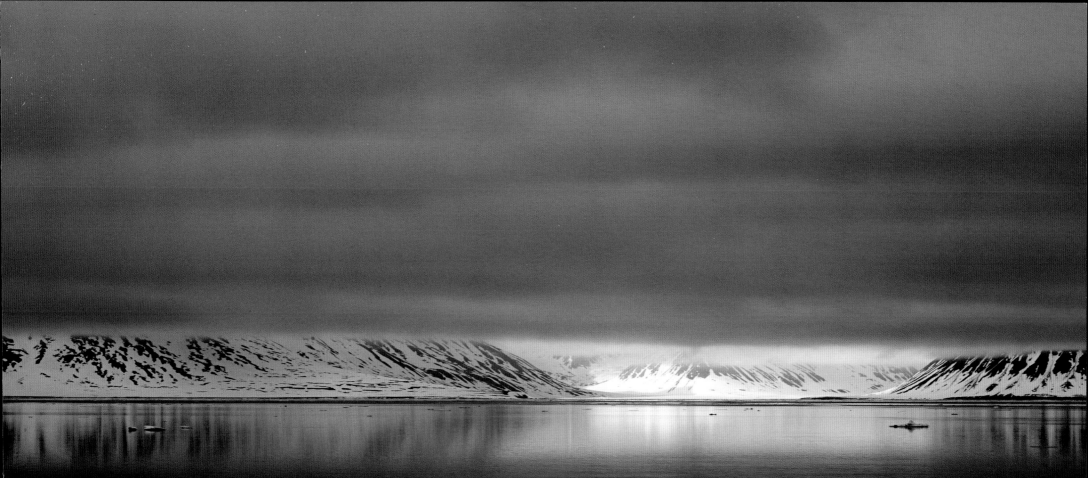

Icebergs Colliding Near Elephant Island

Off the coast of Antartica, February 2010

I was not supposed to be out on deck in the rough seas, but we were passing by the place where, in 1915, Ernest Shackleton's men sheltered for three months after their ship had been crushed by sea ice in the Weddell Sea. Elephant Island is a forsaken place and the darkness that the storm laid over the icebergs and the island and the blackness of the sea itself did not go unfelt by me. As our ship was jostled to and fro in the storm, I silently wept, thinking of how horrible it must have been to eat penguins and shelter seventeen stinky men under a lifeboat in the cold and wet. Not all days are sweet.

overleaf

The Brittle Sea

Svalbard, May 2009

The pale yellow light on the horizon is something I particularly love about the Arctic experience. If you look at the paintings of Caspar David Friedrich, you will find it there as well.

Antarctic Storm

Antarctic Peninsula, December 2008

Antarctica experiences all sorts of extreme weather, including hurricanes. It may not look like it, but as I took this image, the wind was blowing at over seventy-five miles per hour, and the Beaufort wind was a plus twelve. Still, I managed to sneak out on deck and shelter in the shadow of the ship to make this image. Standing out there, it struck me that as massive and ominous as Antarctica is, the sky and its storms made even this landscape look small.

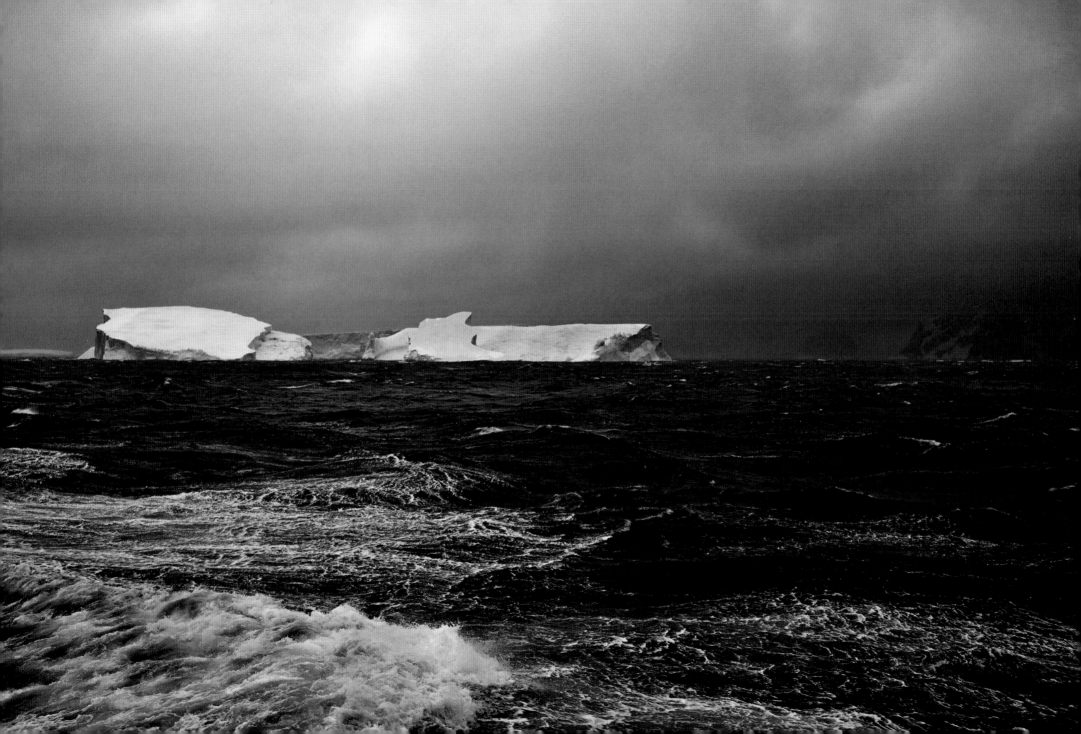

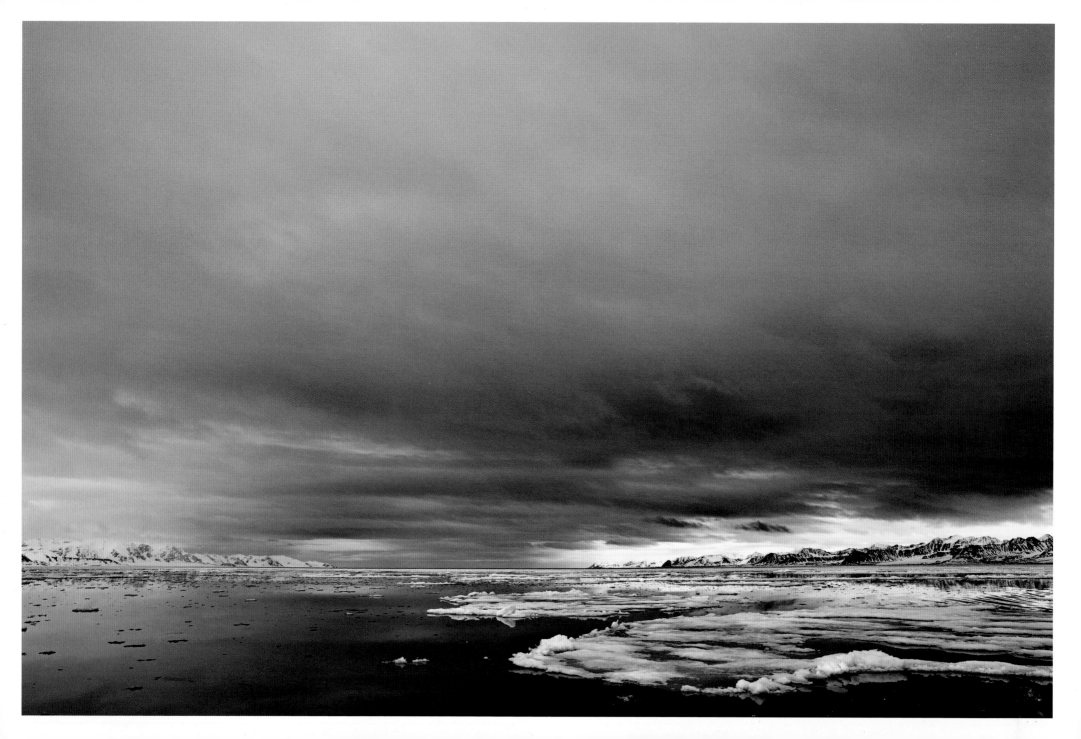

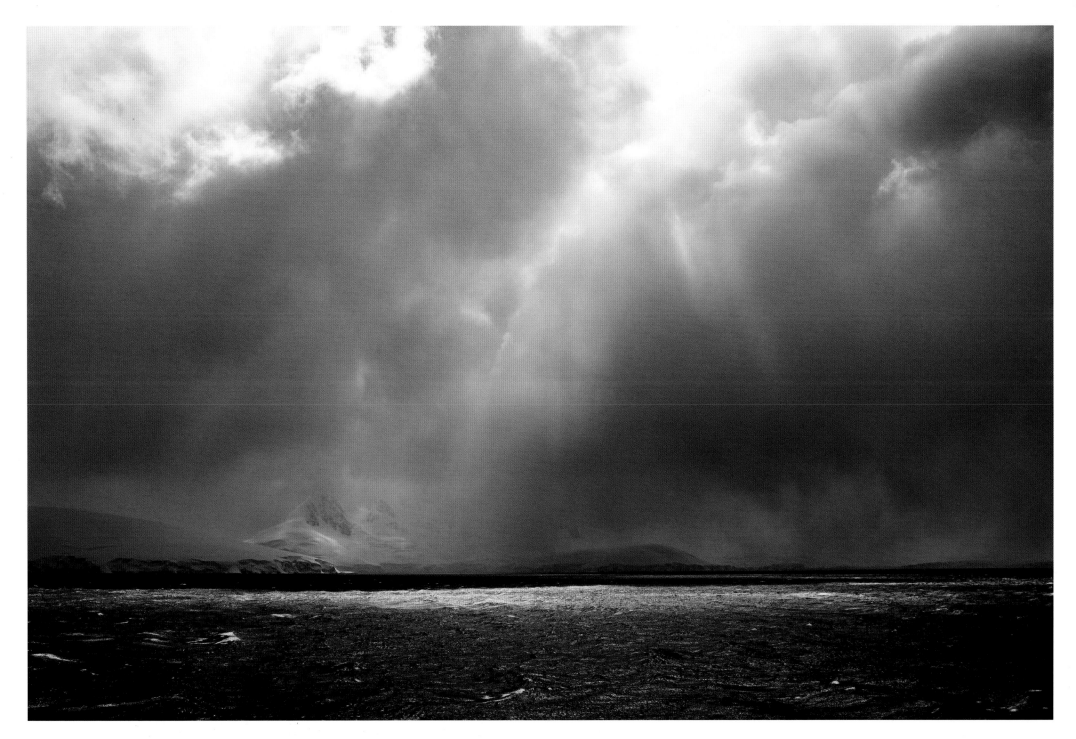

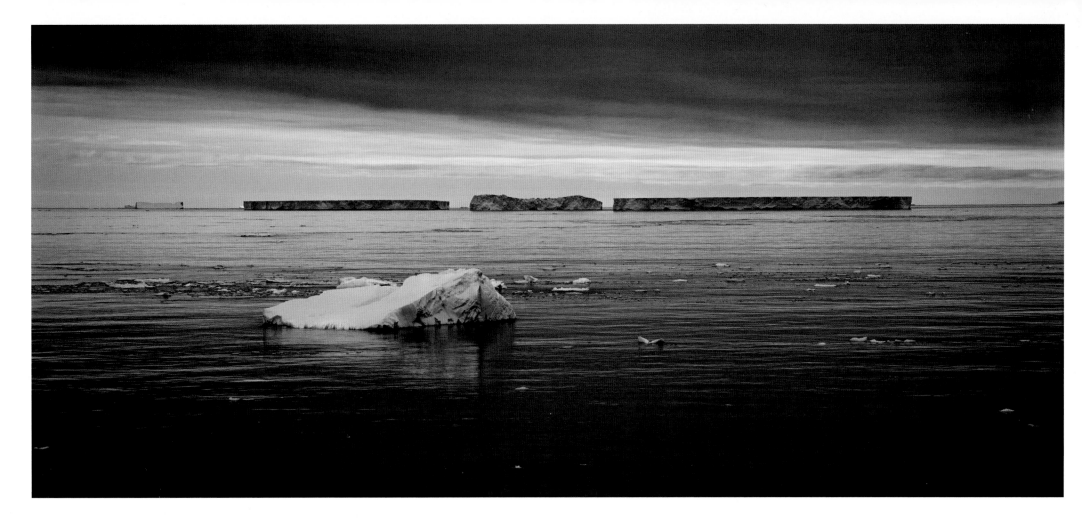

Breaking Up

Antarctic Sound, Antarctica, February 2010

I am constantly amazed by the strange and mysterious behavior of icebergs. I have often watched and waited for seemingly imminent collisions between icebergs, but then they simply glide past each other.

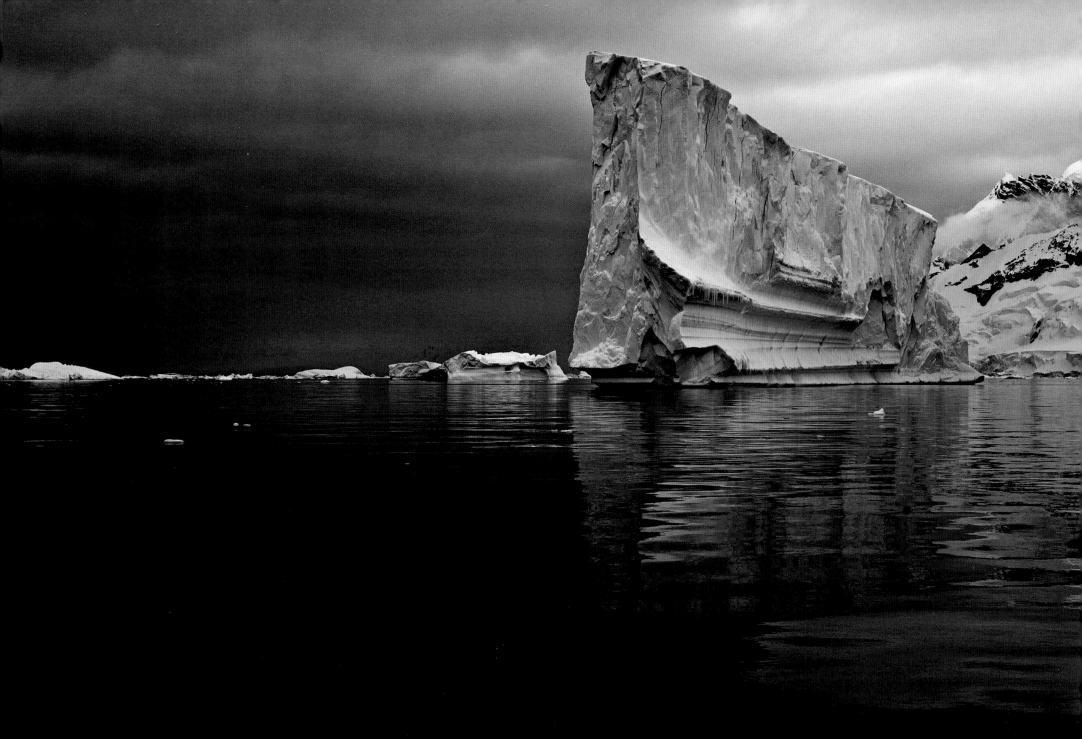

Majestic Iceberg III

Errera Channel, Antarctic Peninsula, December 2007

Sometimes I wish I was absolutely alone in these places. On this day, I was fortunate enough to be in a tiny Zodiac boat with a pilot who was sensitive to how the speed and disturbance of our boat affected the reflections on the water. She let the Zodiac move slowly around and also shut the motor off so as to allow the water to return to its calm mirror–like surface. I am thankful to her for that.

I

It was never a childhood dream of mine to visit the polar regions. I had no real curiosity about those distant, cold places. How strange, then, that both the Arctic and Antarctic should now hold such a power over me.

I have not returned to the poles since late August of 2011. On that last visit, I was heartbroken by the lack of ice. I left my position as ship's photographer aboard the M/V *Fram*, Hurtigruten's most modern expedition cruise vessel. It was the pride of Norway, named for Roald Amundsen's historic polar exploration ship from the 1890s. Until that season, I had never before experienced temperatures so warm in the Arctic. The snow was mostly gone, Jacob's ladder flowers bloomed, and our ship was able to sail far north with no sign of sea ice. That same year, a British teenager was attacked in his tent and killed by a polar bear in the Svalbard region of Norway. It was that same season that my anxiety about bears on land had reached its highest level—I was now dreaming of polar bears. Polar bears everywhere and me looking for escape without alerting them to my proximity. I have the highest respect and reverence for these beautiful and powerful creatures. I never wanted my presence in their environment to be the cause of their death. With so little sea ice, it seemed obvious that the bears could be anywhere on the land. They were constantly on the move, looking for food and places to cool off. Through my lens, I witnessed a young bear swim over five miles, following his nose to a tiny spit of land that served as a nesting site for several species of birds. He then climbed a thirty-foot ridge to reach the nests of birds that had traveled several thousand miles to lay just two eggs. I watched as the hungry bear went from nest to nest, devouring the eggs and young chicks. In less than an hour he had wiped out an entire generation of king eider ducks, common eider ducks, glaucous gulls, kittiwakes and little auks.

After watching this event, I began to see the connections. No sea ice meant a chain reaction that would ripple across the planet. A hungry polar bear might cause a rise in insect populations in Europe. Trees and crops would be affected, causing increased prices due to scarcity. Lack of sea ice also meant a warmer sea. When oceans warm, they expand, raising sea levels and increasing storm surges as well as the frequency of larger more powerful storms as experienced in the eastern United States during Hurricane Sandy in 2012.

I returned to a world that did not seem to care. I saw no real urgency in any government's actions, no obvious signs that people were concerned about the state of our polar regions. Most importantly, I felt despair. I saw no signs that people were even remotely willing to make necessary changes in the way we lived on a daily basis to stem the tide of storms, droughts, and floods that would be heading our way if our poles were ice free. It took me a few weeks to regroup. Spending time with my daughter reminded me that failure was not an option. It was my responsibility to leave this place in a better state than I found it. But one question kept whispering itself in my mind. *Why me?* I felt overwhelmed.

I had first traveled to the Arctic in 1999. I had no idea that that journey would set in motion a series of events that would change my world and reveal my life's work to me. For twelve years, I was like an Arctic tern spending one to three months in the Arctic during the months of May through September, then traveling south to the Antarctic for one to three months of November through February. I was spellbound. I like to tell people I am "bi-polar" in the truest sense of the word. I was getting paid to be on a ship with scientists and tourists all in love with or simply curious about these far ends of our extraordinary planet. I learned so much from the geologists, marine biologists, climatologists, ornithologists, historians, and captains and crew. It was an intensive hands-on education in very special parts of our world. The things I saw humbled me. I understood that very few humans might ever witness what I had the privilege to see, but I also knew that this privilege came with responsibility. I understood that I was recording the voice of these places with my cameras. It was my task to share these voices with those who did not know, did not see

with their own eyes or feel what I felt when I stood there at the poles, camera in hand.

That privilege, that great gift, came with a price, as all great gifts do. I was away from my family, my child. My relationship with my daughter's father was in trouble. My friends did not understand my need to keep going back. I was alone a great deal of the time and that persistent question hung in my mind like a pair of wet socks attempting to dry. Drip, drip, dripping with it's incessant query, *Does it have to be me?*

The way was not always easy. Rough seas, difficult passengers, ship politics. The disintegration of my relationship. Was it worth it? No one even seemed to care or to be taking notice. What difference could I, just one person, make? Was it worth all that I was losing? To feel unheard, unseen? I did not know the answer. However, every time I looked at my daughter, every time I spoke with her, it became clear that I could not give up. I must keep taking the steps, walking forward along the way, and hope that this path would lead somewhere.

Stranded Icebergs Detail II

Cape Bird, Antarctica, December 2006

It was a special treat to be in the Zodiac with fellow photographer John Weller and John Palmer as our pilot. We casually cruised around these "stranded" icebergs (icebergs stuck on the rocky bottoms of the shallow coast) while we kept a safe distance. We had ample opportunity to admire the subtle colors of algae in the ice: pinks, browns, and pale greens.

overleaf

Terminus, Raudfjord

Svalbard, June 2010

Svalbard's glaciers are like great secrets that whisper and murmur but never reveal their hearts.

Bergy Bits Jammed Up in the Errera Channel

Antarctic Peninsula, December 2007

Here, currents and tides drew many hundreds of bergy bits together in a massive sort of logjam. The weather was foggy and the mountain behind was mostly obscured in the mist.

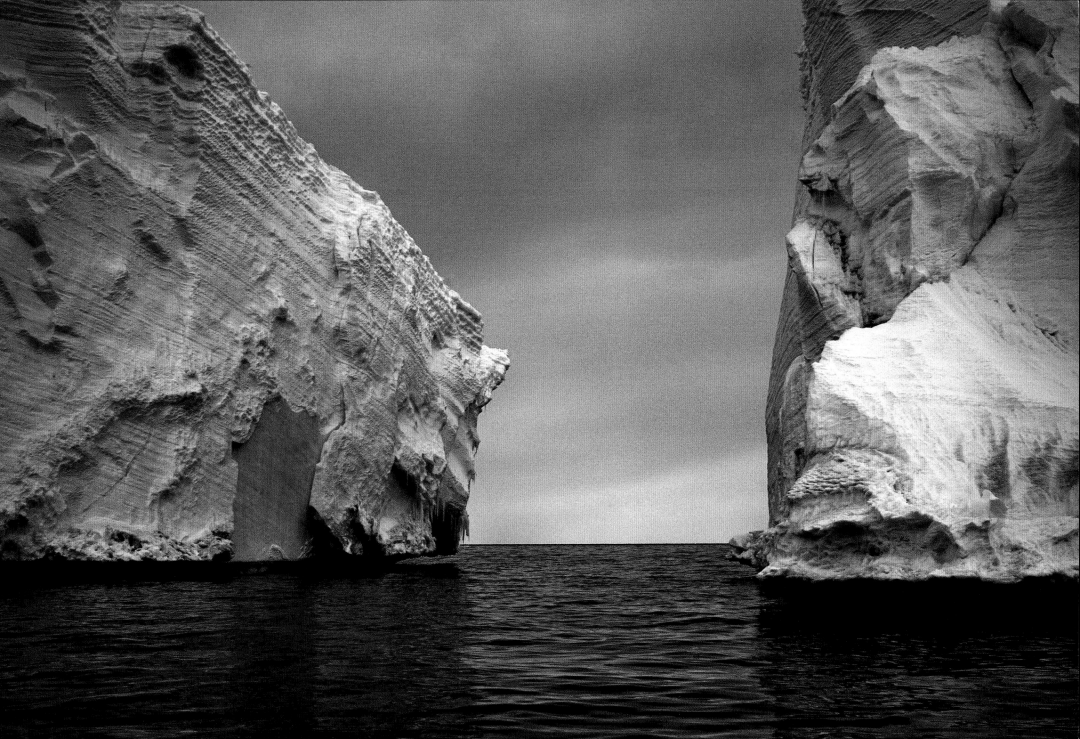

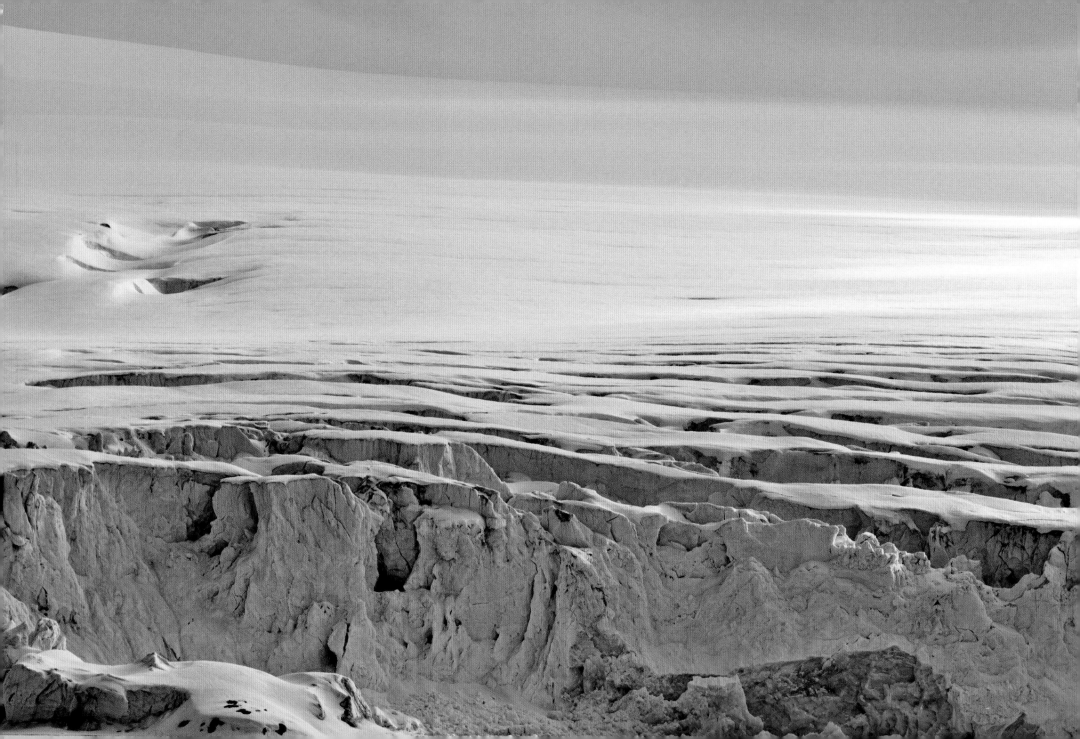

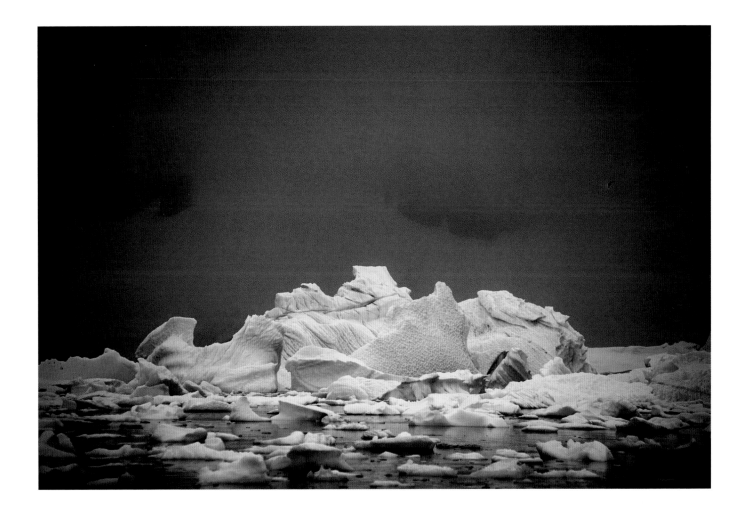

Breaching Iceberg

Greenland, August 2008

I only made one exposure of this scene, as the sea was a bit choppy.
I was lucky with overcast skies and when I saw this light and the
gesture of the iceberg I took my shot.

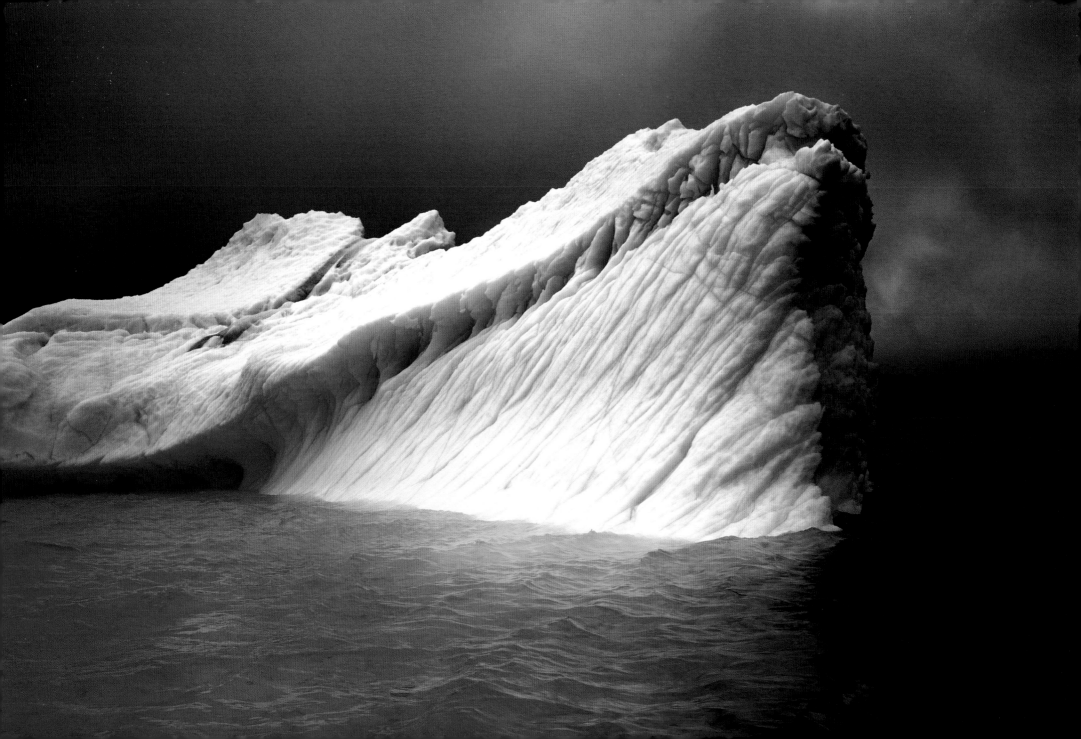

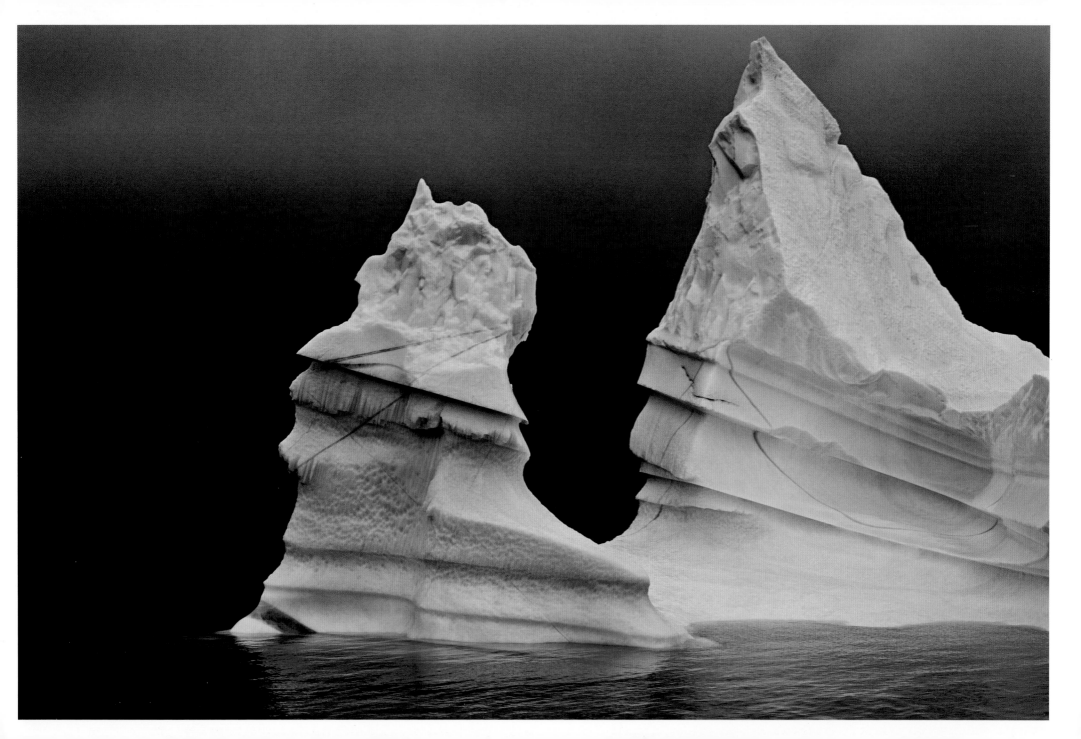

Grand Pinnacle Iceberg Detail

Eastern Greenland, August 2006

There are several types of iceberg shape and size classifications.
This pinnacle iceberg was quite spectacular.

Looking at the Icebergs

The Ross Sea off Franklin Island, Antarctica, December 2006

John Palmer is a medical doctor from Australia. When he is onboard the I/B *Kapitan Klebnikov* as resident doctor, his duties also include acting as the traffic operator for the ship's two helicopters. Here, he looks off into the distance where two massive icebergs are about to collide in a strong swell. One of the helicopters (too small to see in this image) had flown out to observe the icebergs up close.

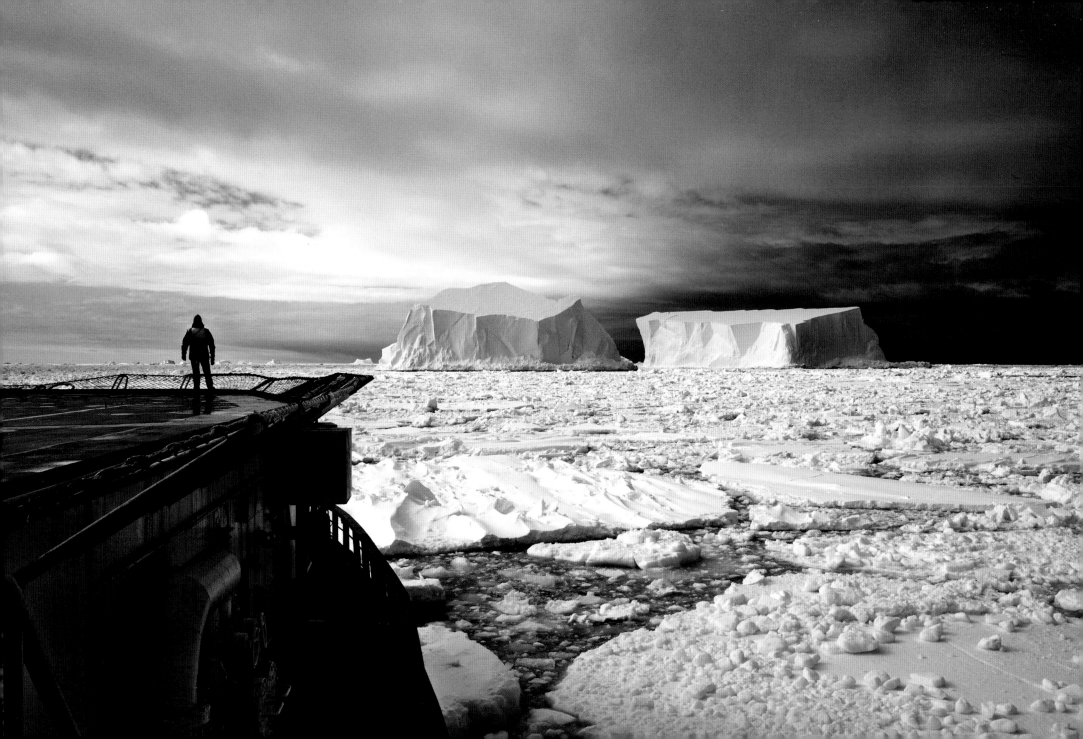

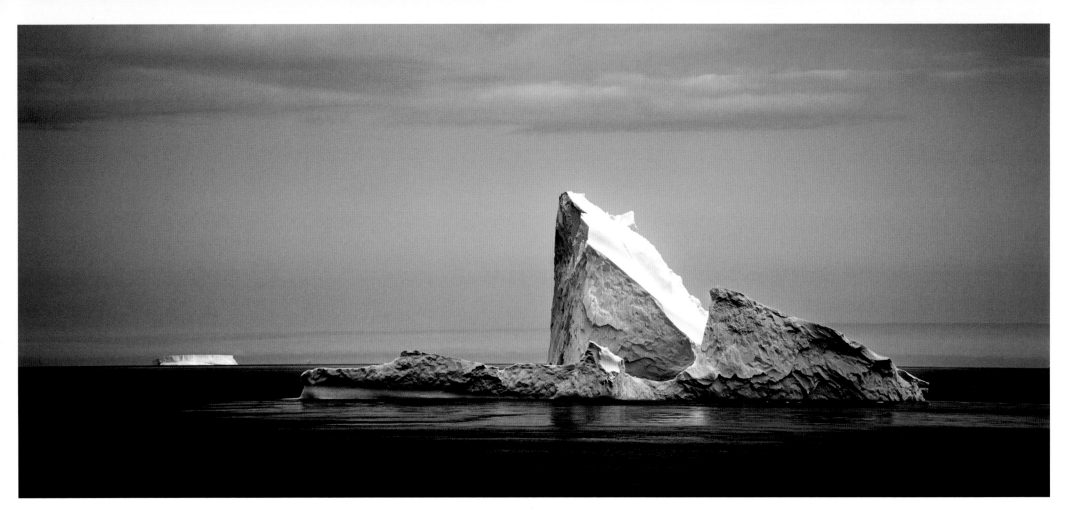

The Shape of Things to Come

Antarctic Sound, February 2010

As we sailed with the land to our backs, I saw this bright, jagged
iceberg with a dark-blue sea beyond. As we sailed around and past it,
the far side turned out to have a completely different shape, starkly
set against the glowering ice of the continent.

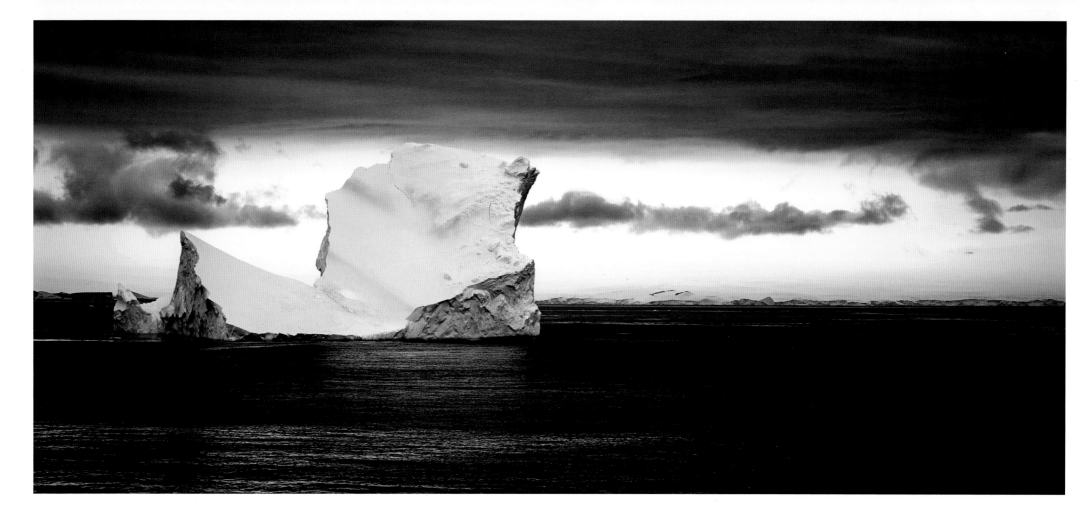

The Shape of Things to Come II
Antarctic Sound, Antarctica, February 2010

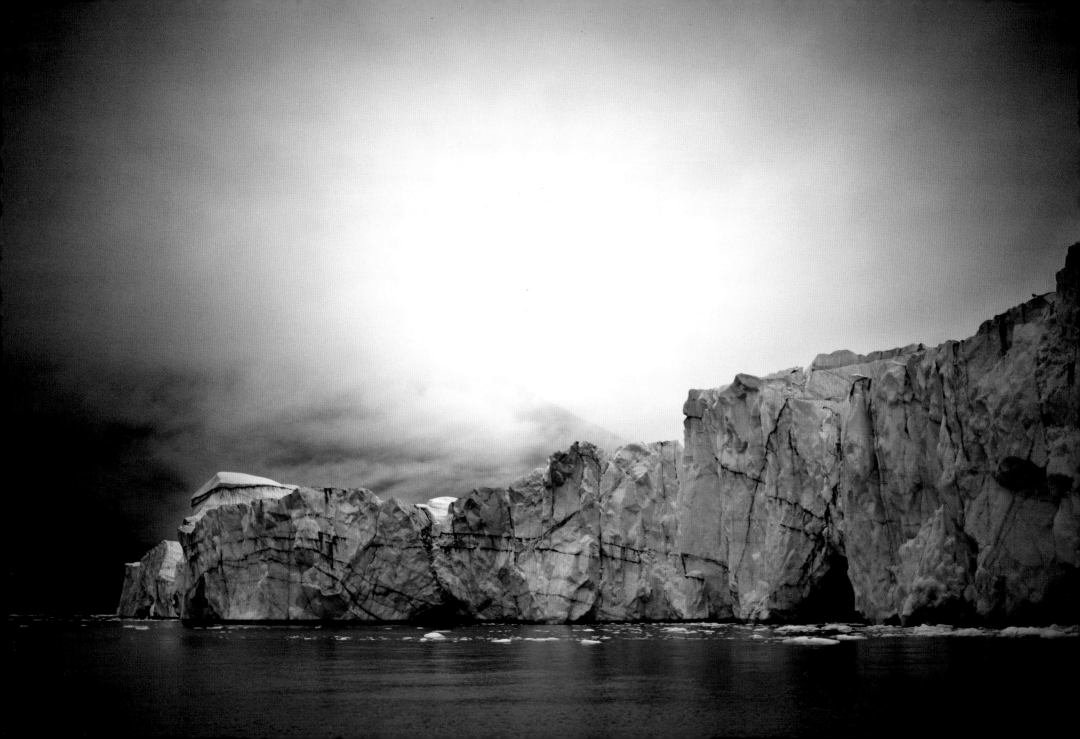

Brae Glacier, Scoresbysund

Eastern Greenland, August 2006

Glaciers lead a very tumultuous life. As they travel downslope toward
the sea they are constantly being shifted, pulled, and churned in
numerous directions. This particular glacier displays the many layers
of earth that it has chiseled and grated from the rock it slowly grinds
over. The black stripes are indications of the many ways the ice has
been jostled over the eons.

Walking on the Frozen Sea Ice

Cape Washington, Antarctica, December 2006

After two days of our ship shoved into the sea ice during a blind blizzard, the weather finally cleared. It was safe enough to allow two expedition staff members roped to each other to test the thickness of the sea ice. On the ice, they laid a path for the passengers to reach the massive icebergs and visit a nearby emperor penguin colony.

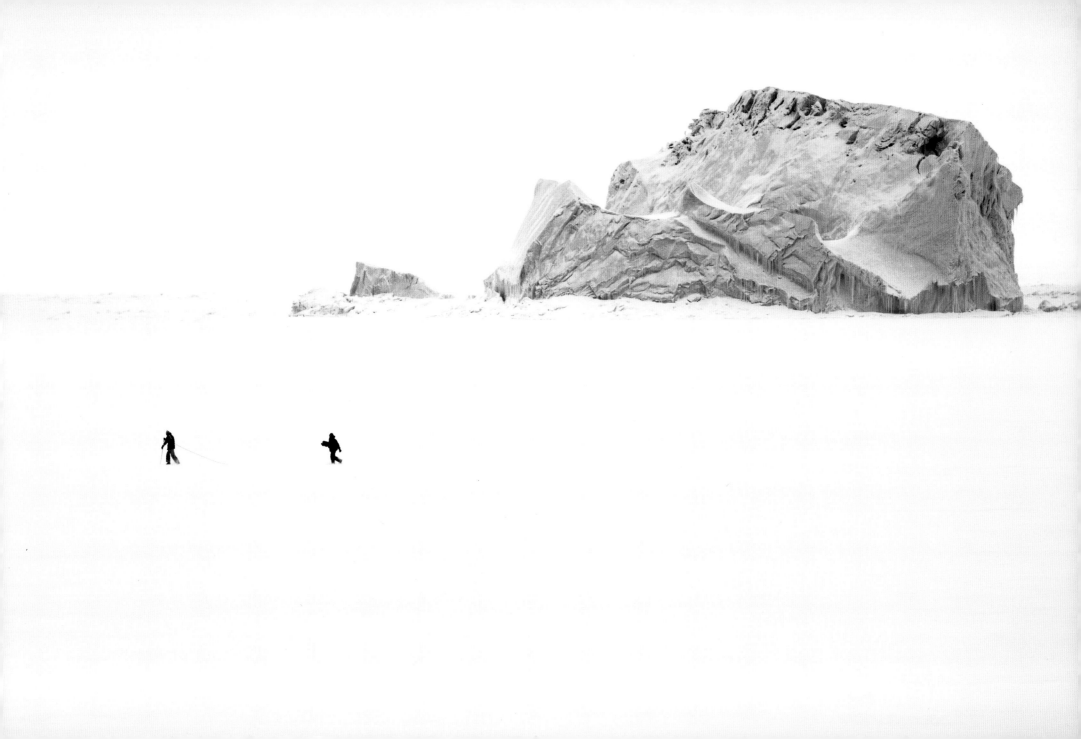

Iceberg Detail with Kittiwake Gulls

Eastern Greenland, August 2006

As our ship passed by this iceberg, which stood some three hundred feet out of the water, the birds were disturbed enough to leave their resting spots. I love the elephant–skin quality of the surface of this berg.

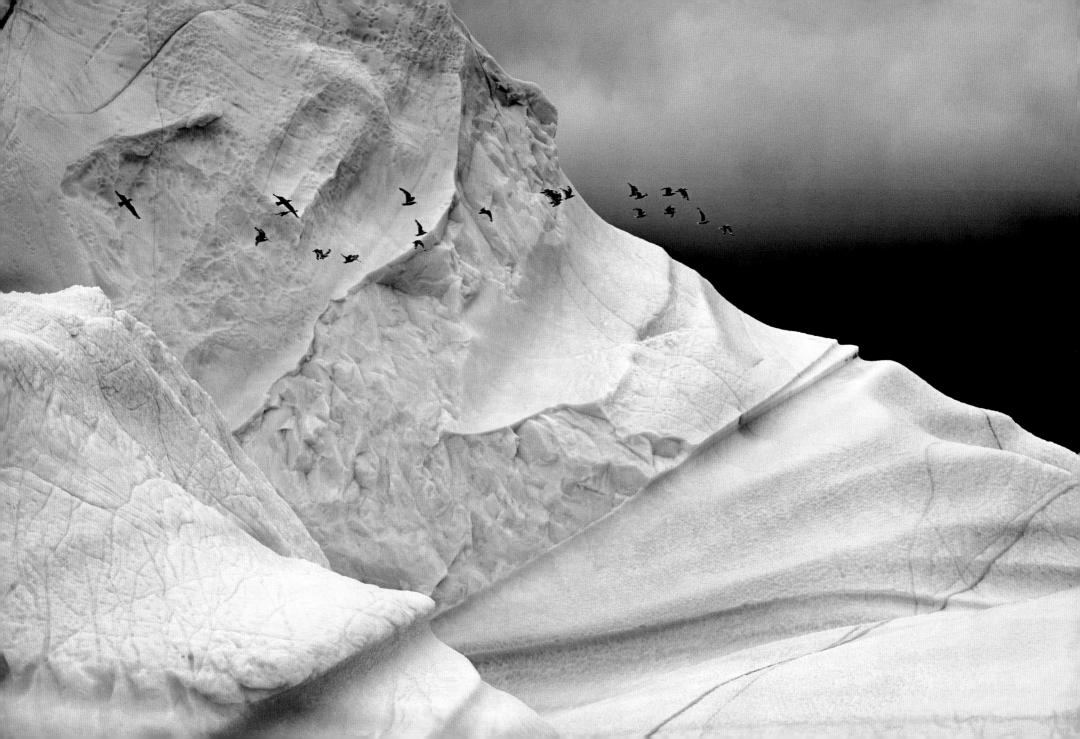

I I

As a small child, I remember holding a Kodak 110 film camera in my hands. "Let Camille take the picture," family members would say. "She doesn't cut our heads off!" Beyond taking pictures of my family, I didn't think my interest or ability with a camera was anything special.

By the time I was fifteen years old, things were pretty unbearable at home. My mother, brother, younger sister, and I were living in the unfinished attic of a strange woman's house in Jamaica, Queens. I was a visual arts student at the Fiorello H. LaGuardia High School of Music and Art in Manhattan. Relations with my mother had been disintegrating since I was thirteen. My acceptance into the "Fame" school meant we had to move into New York City. She blamed me for dragging her back to the city that she thought she had escaped. She told me daily of her great sacrifice, of how much I had cost her. She did not seem to understand me. I could not take the pressure of that ache any longer, and so I left home. I began sleeping on the couches of my punk rock friends and at the home of my great-uncle.

I worked several after-school jobs to support myself. My first job was as a cashier at Woolworth's (I lied about my age and told them I was sixteen). I then zipped around the city as a bike messenger—not a typical job for a girl. Later I worked in a one-hour photo lab. My high school recognized that I was at risk. I was a homeless teenage girl and could easily fall through the cracks and end up in a hopeless situation. I was recommended to join an after-school program where I was given a Nikkormat film camera, but no manual. I was told I must learn how to use the camera on my own. They did, however, teach me how to bulk load black-and-white film and how to enlarge and develop the images in a wet darkroom. After that, they said, "Now go out and photograph your experience." And so I did.

We were teenagers, punk rockers, art school hags. New York City was our playground. We could go anywhere. We stayed out late, sometimes till dawn, and found all sorts of trouble. I photographed everything—all my friends, all of our adventures. I realized having that camera in my hands gave me excuses to be somewhere in a positive way. Some of my friends were getting into trouble with alcohol and drugs and whatever, but, camera in hand, I had something that kept me focused and on track. I really didn't think of myself as a photographer. It was just something I did.

High school was great, instilling discipline and practice. As students of LaGuardia, we had great exposure. We were required to go to a museum every week, and being in Manhattan, we had access to some of the most amazing collections of all of art history. I never took such access for granted. I went to museums and stayed for hours. In fact, whenever I would go to the Metropolitan Museum, they would say, "Oh, she's back." They would assign a guard to me because I would get so close to the Rodin sculptures. I would stand really close to Monet's water lilies. I wanted to see how the marble was carved, how the paint was laid on.

The camera granted me a positive activity in a potentially destructive situation. I was an angry, confused young woman and having that camera in my hands was like handing me a hammer to smash through those stones of anger and confusion. I didn't realize it then, but that camera and its focus probably saved my life. With that instrument of creativity in my hands, I could peacefully express whatever powerful emotions I was feeling.

After high school I went to university and then subsequently moved to California. I traveled a great deal and always had my camera by my side. Still, I never considered myself to be a photographer, nor did I ever consider that I might make a career as one. It was not yet obvious that my experience with a camera during my teenage years had planted a seed that was slowly taking root and would someday blossom.

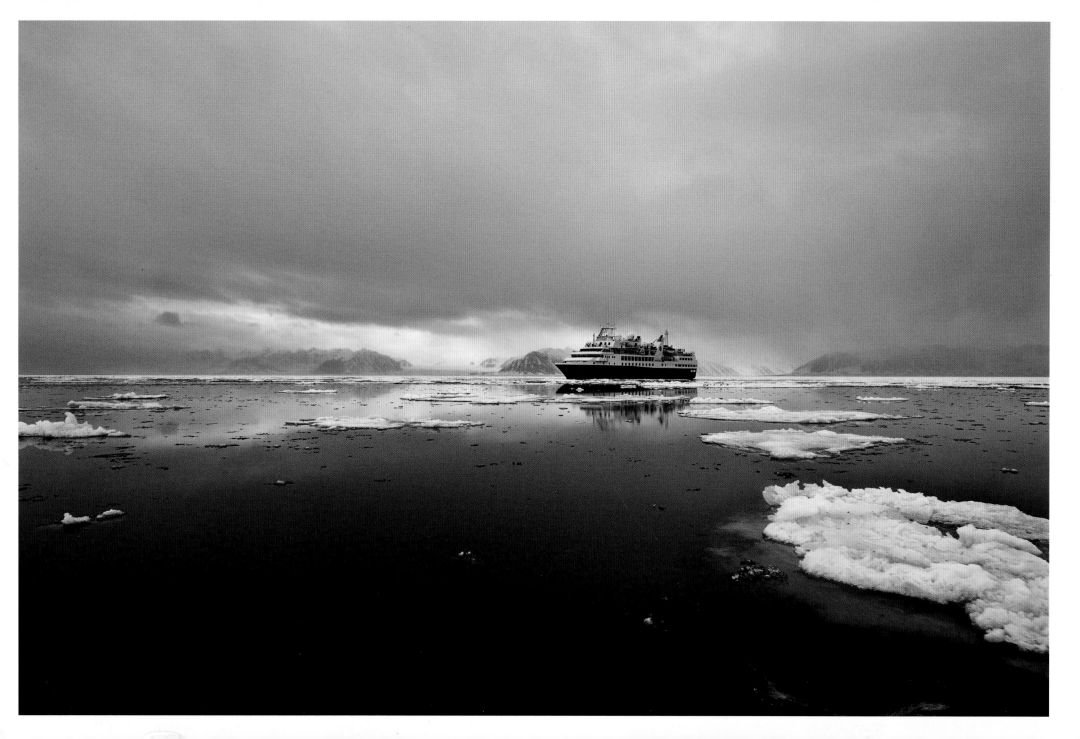

M/V *Prince Albert II Bellsund*
Svalbard, May 2009

Being so far north often felt like a dream: the silence, the otherworldly quality of the light. The utter stillness drew me back to the polar regions year after year. Spending extended periods of time here evokes a deep sense of peace. Perhaps the combined conditions create this feeling or maybe it is being so far removed from civilization at the top of the planet. It is easy to feel small here. Easy to feel fragile.

Rasmussen Glacier

Scoresbysund, eastern Greenland, August 2006

Not many people on the planet get to spend time on the east side of
Greenland. Those who visit Scoresbysund are rarely disappointed.
The jaw-dropping vista of the Rasmussen Glacier is epic on any day.

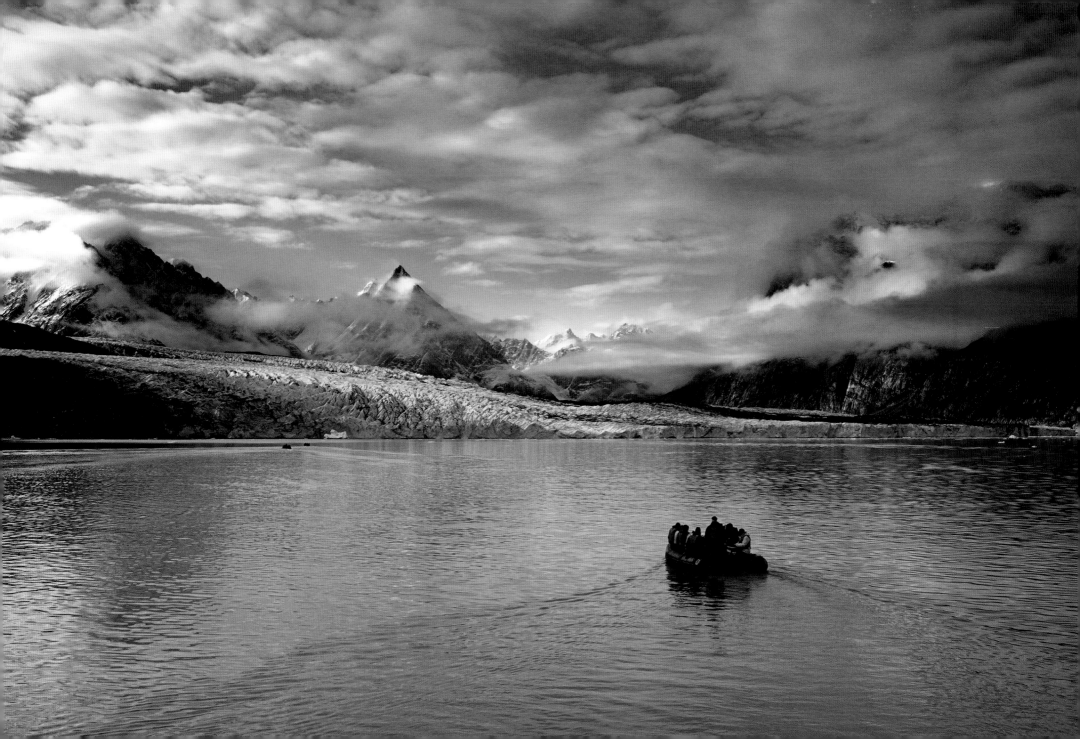

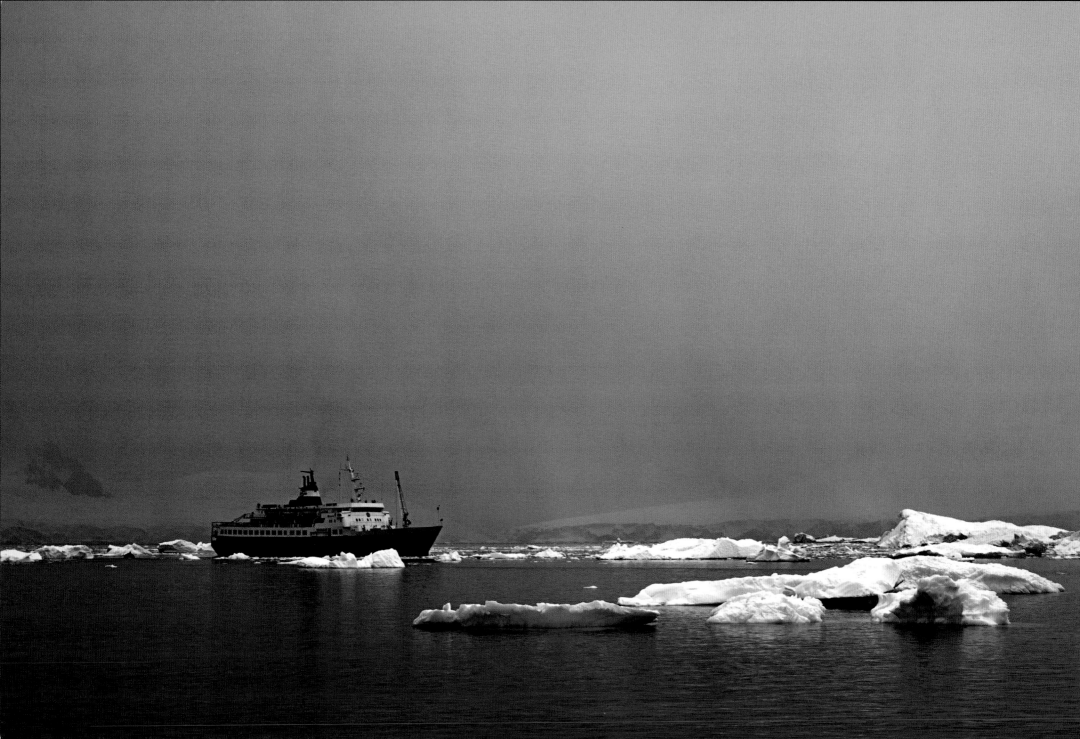

M/V *Lyubov Orlova*

Errera Channel, Antarctica, December 2007

At one point in my time on this rickety old ship, my cabin was close
to the engine room and my tiny porthole leaked water as waves crashed
against it in a dazzling display. The ship was pulled out of service
in 2010 and it sat in Saint John's, Newfoundland, for two years. The
Lyubov Orlova's decommissioning was fraught with problems and
the ship eventually became a floating derelict in the North Atlantic
Ocean in 2013. It is believed to have sunk.

Those Who Came to See for Themselves

Eastern Greenland, August 2006

One of the things that kept me coming back to the Arctic was the
dreamlike days of absolute calm. On such days the sea was a silver
mirror and the silence was a beautiful blanket wrapped around me.
On this particular day we shoved our small rubber boats up onto
the floe and stood on thin ice, feeling quite precarious.

overleaf

The Visitors

Rolige Brae Glacier, Scoresbysund, eastern Greenland, August 2006

Glaciers are unpredictable creatures, always shifting, creaking, and
booming. It is not uncommon for pieces of a glacier to break off from
the underside of the terminus and for this reason we always keep
a good distance away. Even with a camera, the scale is difficult to
communicate. In this image, the Zodiac is actually at least 1,500 feet
from the face of the glacier.

Stranded Iceberg

Cape Bird, Antarctica, December 2006

It was Christmas Day. I was feeling a bit melancholy about being so
far away from my seven-year-old daughter. As our ship, the I/B
Kapitan Klebnikov, approached Ross Island we could smell and hear
the Adelie penguin colony long before we could make out their shapes
on the shore.

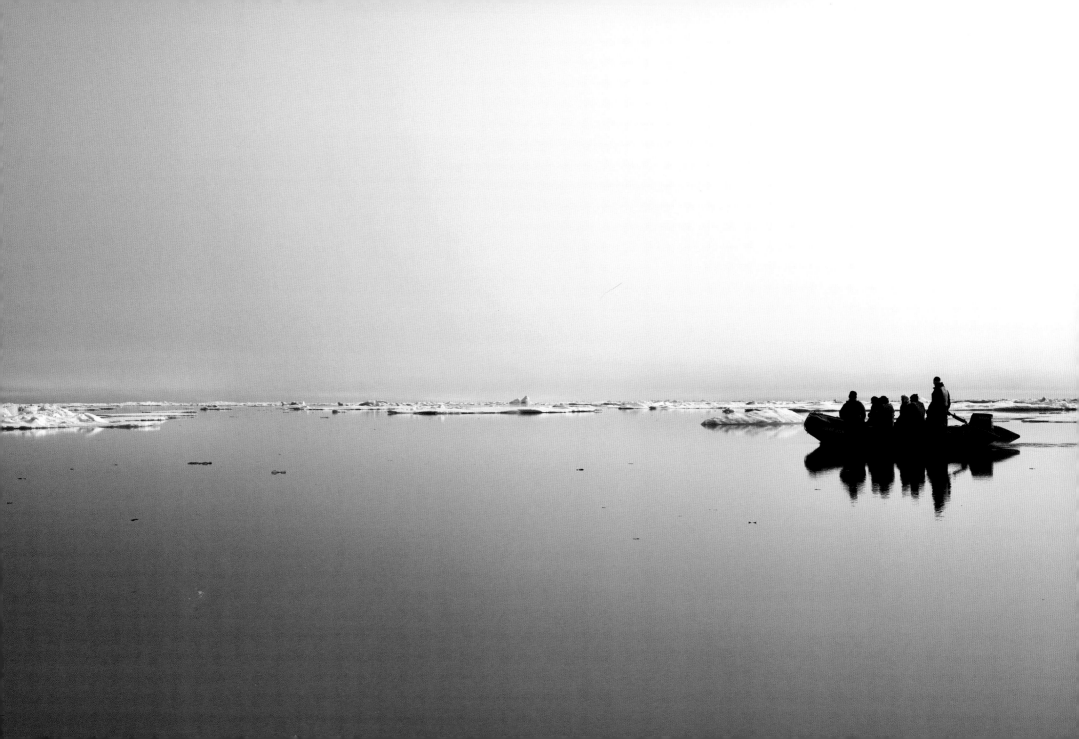

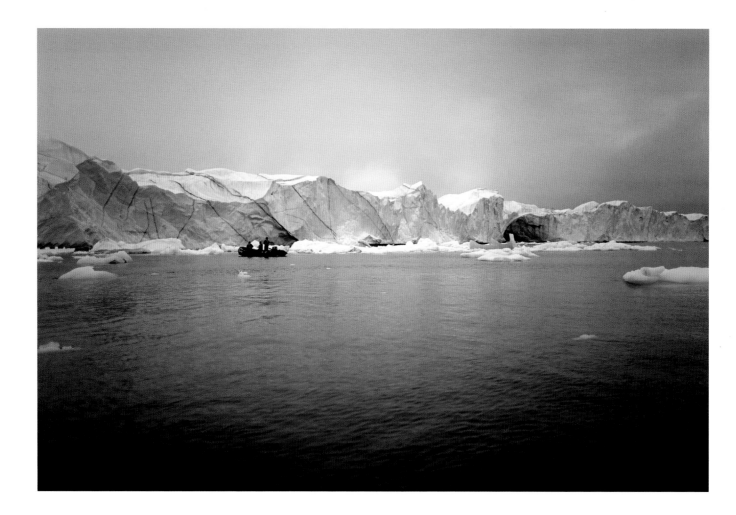

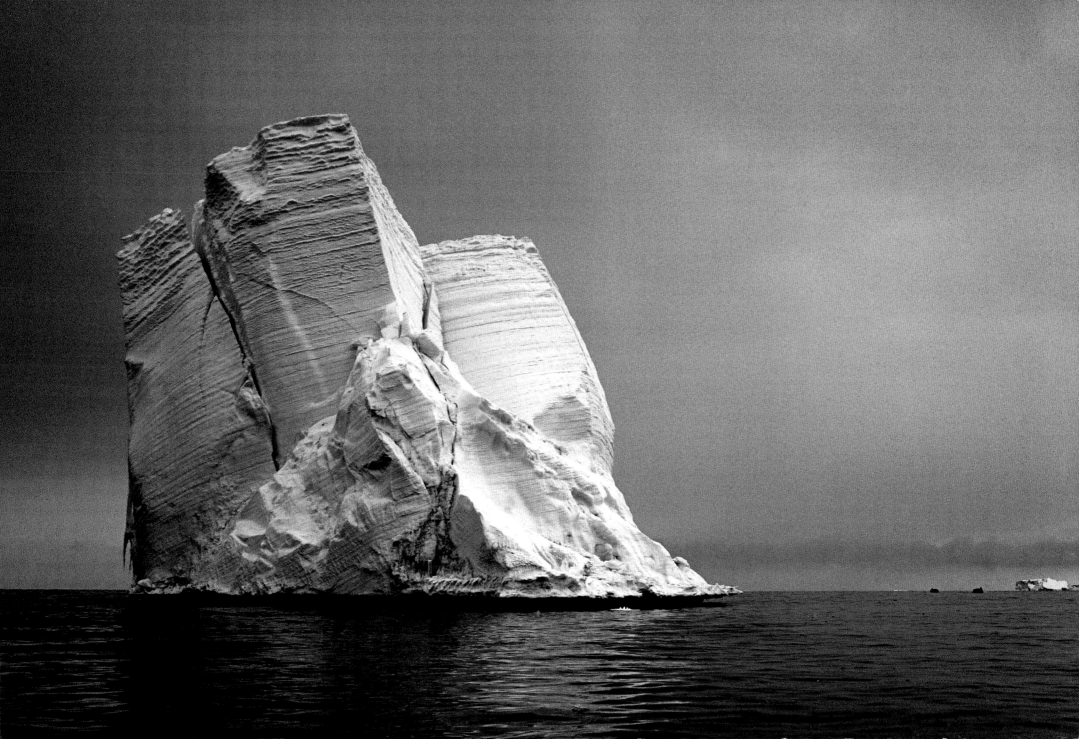

The Emperor's Visitors

Cape Washington, Antarctica, December, 2006

It had snowed for days. Big, white, heavy snowflakes the size of
half dollars ceaselessly bombarded the Antarctic stillness. Sound was
muffled. Only the distant call of the emperor penguins haunted the
whiteness. After two days of the ship being parked into the frozen
sea ice, the snowstorm subsided.

The expedition crew sent out two men to flag a safe path. Then,
the passengers, intrepid tourists from all over the globe, walked
on the frozen sea, inching ever closer to the visiting emperors,
as they themselves inched towards us to see what sort of creatures
we might be.

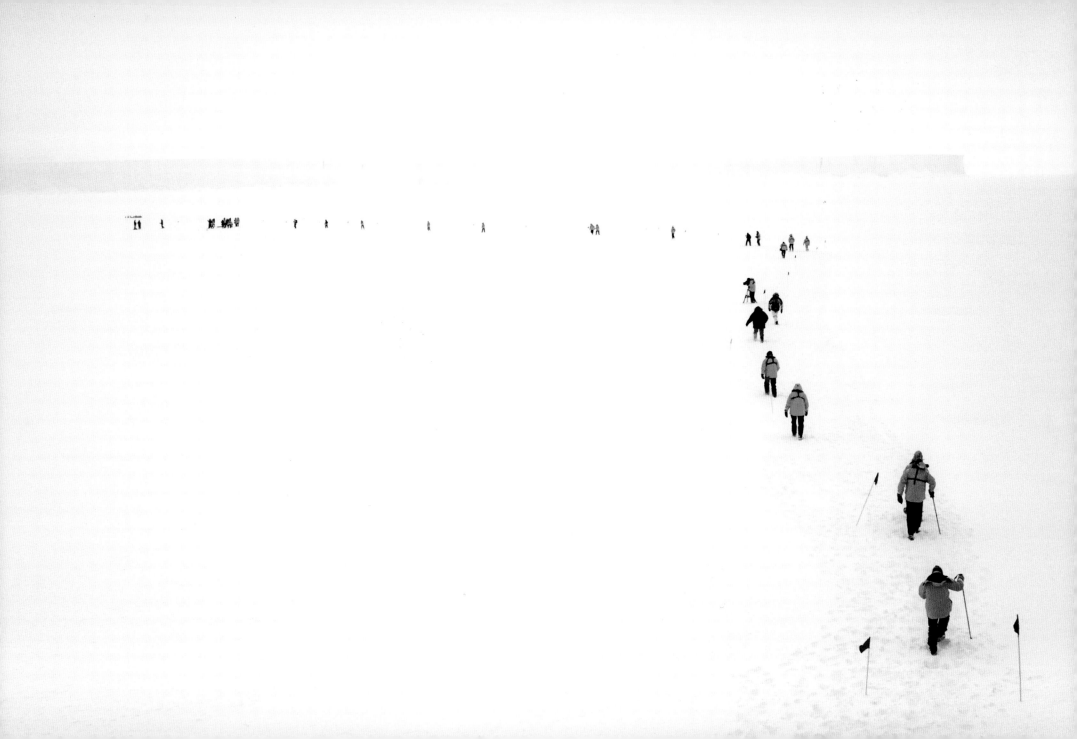

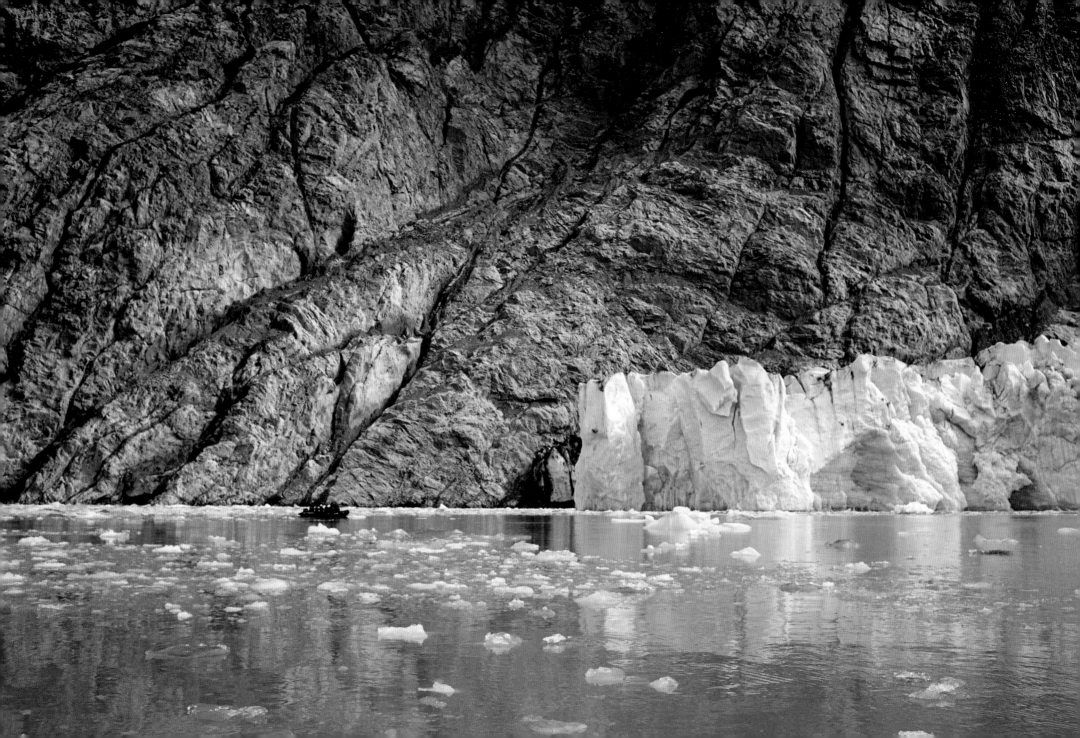

The Different Faces of Time

Southern Greenland, August 2008

Juan Carlos, the expedition geologist, told me in his endearingly thick Colombian accent that the stone we were looking at was some of the oldest exposed granite on the planet, estimated to be 3.66 billion years old. The glacier that rests along the stone face is a mere shadow of its former self, yet it still loomed large over our Zodiac. As the ice cracks, breaks, and melts, we say that it "retreats." It feels like something more. I feel small as I see the tiny boat with our passengers, against the blue ice that looks puny against the ancient stone. Stone that withstands in its own way the carving, the grinding, bearing the scars of its slow dance with the ice.

III

I was the oldest child of my African American-Italian mother and my Shinnecock father. Being around my father's family on Long Island, I was continually exposed to the Shinnecock traditions, which gave me a unique upbringing. Our small fishing tribe is from the southern fork of eastern Long Island near the town of South Hampton. There are about 1,300 Shinnecock with some 600 residing on the small 800-acre reservation. My family was fortunate enough to live away from the reservation. We primarily lived in the town of Huntington.

We lived on "the Hill." Even when my grandfather was growing up, they called it Crow Hill. It was an isolated little hill surrounded by the town of Huntington. My family fished almost daily. We had very little money and yet there was nothing we ever needed. We were resourceful and creative. We had chickens, ducks and geese, sometimes even rabbits. Nana had a large garden in which my grandfather would bury discarded fish heads. This was an ancient and effective way to fertilize the garden. We grew many of our own vegetables. We did not live like other people in that area. I don't think anyone else in town had chickens or a garden the size of ours, or shot squirrels in the woods or trapped raccoons to eat. That is how we fed ourselves. We grew up playing with earth.

I had no understanding of just how different my early childhood was compared to that of my classmates. In my family, we knew who we were, but I do not think we advertised that secure knowledge very much. It was not fashionable to be native, or of color—even by the time I was born—and my parents were mixed race. They had married in 1969, only about a year after it had become legal for different races to intermarry.

My grandfather was an impressive man, partly because he had no teeth left in his mouth yet refused to wear his dentures. Everything he said was mumbled. He would even eat corn on the cob with no teeth. Sometimes he would get so frustrated if we did not understand him and he had to repeat himself, but one thing he always made clear. There was to be no inequality between men and women in our family. We girls were encouraged to be outgoing and to do our best. My grandfather encouraged me to play Babe Ruth baseball with boys, and I was the only girl on the team. In fact, I was the thirteenth girl in the United States to play Babe Ruth baseball. There was some controversy about me being the only girl on a hardball team, but my grandfather stood firm, encouraging me not to let anyone keep me from being my best.

Grandpa would teach us things. He always had lessons for us. He would not just teach us by telling stories; he would actually take us outside and show us. Once, when I was five or six years old, he took me and some of my cousins outside on a hot cloudless summer day. He sat us down in a field of grass and said nothing. We sat there for some time until it started getting very warm. My cousins and I were really starting to perspire. Only then did my grandfather lift his arm and point to the sky where a small white tuft of cloud began to appear. He said, "Do you see that? That is part of you up there. Your water helps to make the cloud which makes the rain which waters the plants that feed the animals." He was illustrating that cycle, telling us there was no such thing as separation. Our water, our perspiration, is recycled. Everything in our body is recycled. We are literally part of everything.

On another occasion he took me alone into the woods for a walk. He would patiently stop at each tree and introduce me to the tree as if he were introducing me to a person. He would have me look carefully at the shape and form of the tree, the way the branches were and the texture of the bark. Grandpa would have me hold the tree and tell me to slow my breathing. "Quiet your mind," he would say, "Listen. Listen to the tree." I could hear it moving. That massive thing was moving subtly beneath my hands. I understood that this was a living thing. It was moving at a much slower pace than we do as humans, but it was

most certainly alive. A side effect of my grandfather introducing me to the trees in the woods that way was that I knew those trees. They became individuals to me, not just a pine or an oak. I never got lost.

The world of my father's family was very different from the town and society in which we lived. As a child I felt conflicted about my identity. I was not black enough to be black, not Indian enough to be Indian, and not Italian enough to be Italian. I was other. I sat on the outside as an observer. I understood being on the outside had its unique advantages. I understood borders in the way that only someone who lives on a border can, I was able to cross and dissolve those borders. I could not be excluded, and I could create bridges when needed between racial groups. Slowly, I embraced my difference. I embraced that I was not like the others. In that embrace, I found strength, especially as a young girl. I didn't need to try to fit in. I just lived my own truth, and that life in truth gave me a valuable head start.

When my parents divorced, my brother and I first lived with my father back at my grandparents' house on the hill. Eventually, my mom took us, and then the troubles between us really began. It wasn't until I was at university that I began to reconnect with my native heritage. It was only because of my great-uncle Sonny that I even applied to college.

Uncle Sonny was the great uncle who had allowed me to stay with him several nights a week when I was a homeless teen. As my senior year drew to a close, he sat down with me and helped me fill out several college applications (schools he insisted I apply to) and financial aid forms. When I was accepted to the State University of New York at Purchase, he drove me there. At Purchase, I was lucky to study with John Cohen. Although well-known as a musician from the New Lost City Ramblers and as a renowned photographer and filmmaker, he was my drawing teacher. John would take our class outside into the lush fields surrounding the Purchase campus, and we would sit and draw for hours. He spoke to me about his trips to the Peruvian Andes, the people there, their culture, describing how he photographed and filmed them while recording their traditional songs. His stories sparked something in me, awakened my family heart. "I have a heritage. I need to pay more attention to it." I started doing beadwork again. Every summer break, I would travel to different reservations in different states, seeking others like me, sharing stories, experiences, and techniques of beadwork or quillwork.

Relics of Port Lockroy

Wiencke Island, Antarctica, February 2010

It was the instrumental use of sledge dogs by Roald Amundsen that made his team the first to reach the South Pole in 1911. Eighty-three years later, all dogs were removed from the Antarctic continent, decreed so by a protocol aiming to keep nonnative species and their possible diseases from affecting native flora and fauna. This abandoned dog sledge is a reminder of the heroic age of expeditions on the continent.

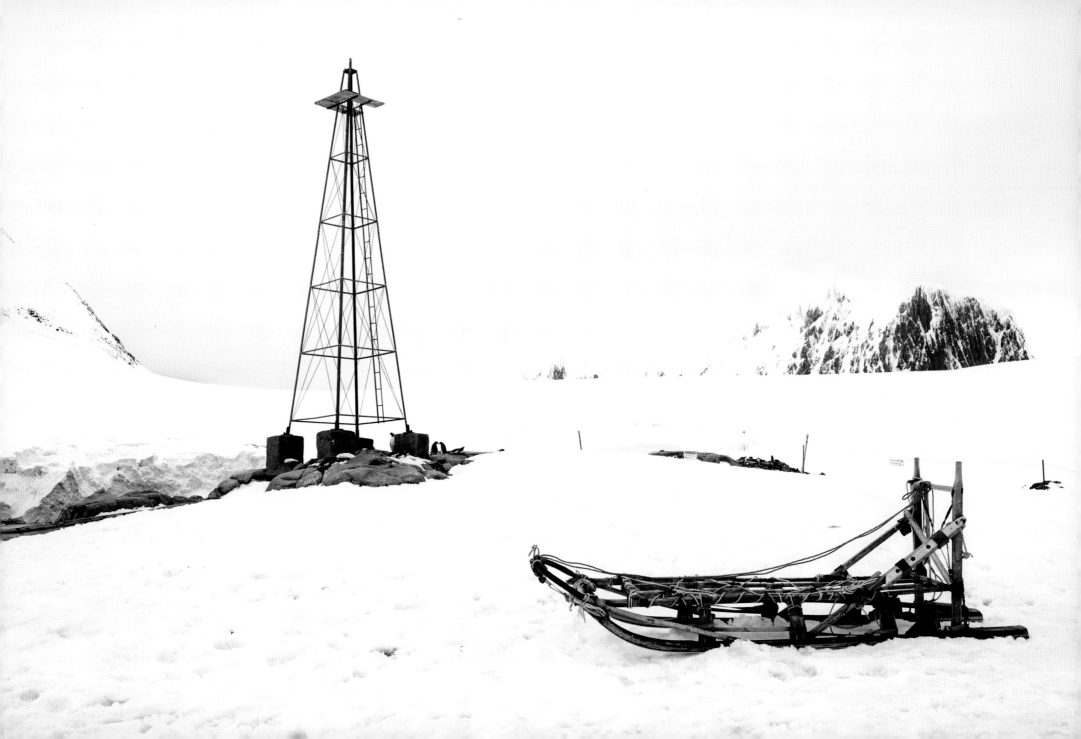

Almost Obliterated

Deception Island, Antarctica, December, 2008

For many years, whaling was the chief operation of the humans who ventured to the Antarctic. Here, in 1969, the earth beneath the men's feet awoke in a violent volcanic eruption as if in protest of the carnage that had taken place here. Now the flooded caldera is a lunar landscape. A popular destination for tourists to see a place where the earth has reclaimed land from humans by means of fire, ice, water, and wind. This island laughs at the triviality of human endeavor and the destruction reminds us that we all return to the source.

overleaf

Whale Vertebra, Bamsebu Hut

Van Keulenfjorden, Svalbard, June 2010

Whalers first started using this beach in the early 1600s and left for good in the 1930s. Now the beach is home to the cabin of a Norwegian family. The hut is covered with outward pointing nails to discourage polar bears from trying to push against it.

Kayak Skeletons

Sisimiut, Greenland, August 2009

He had green eyes and his sandy-brown hair was sticking out from his knit hat as he applied paint to the kayak frame. He was young. His mother was Inuit and his father was Danish. He told me that making the kayak in the old way was important, that the old ways must not only be remembered, but kept alive. He and his brother both built their kayaks themselves and had mastered the many different ways to roll their kayak. They even don traditional sealskin suits while competing in national competitions. He said it keeps him out of trouble.

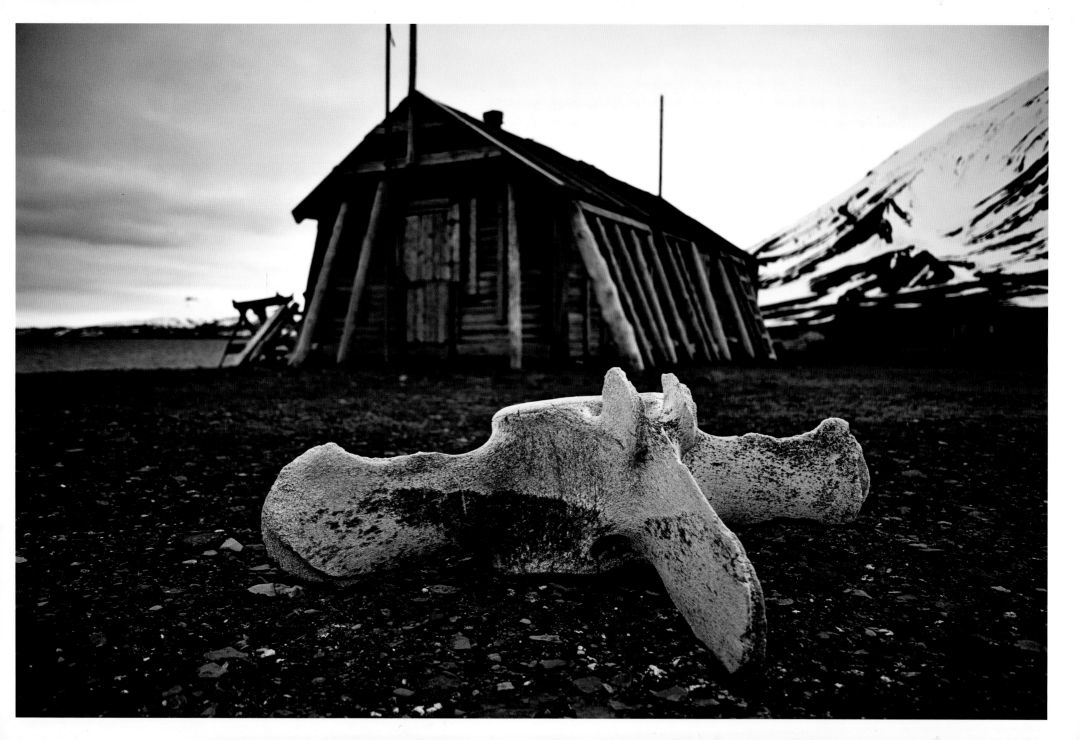

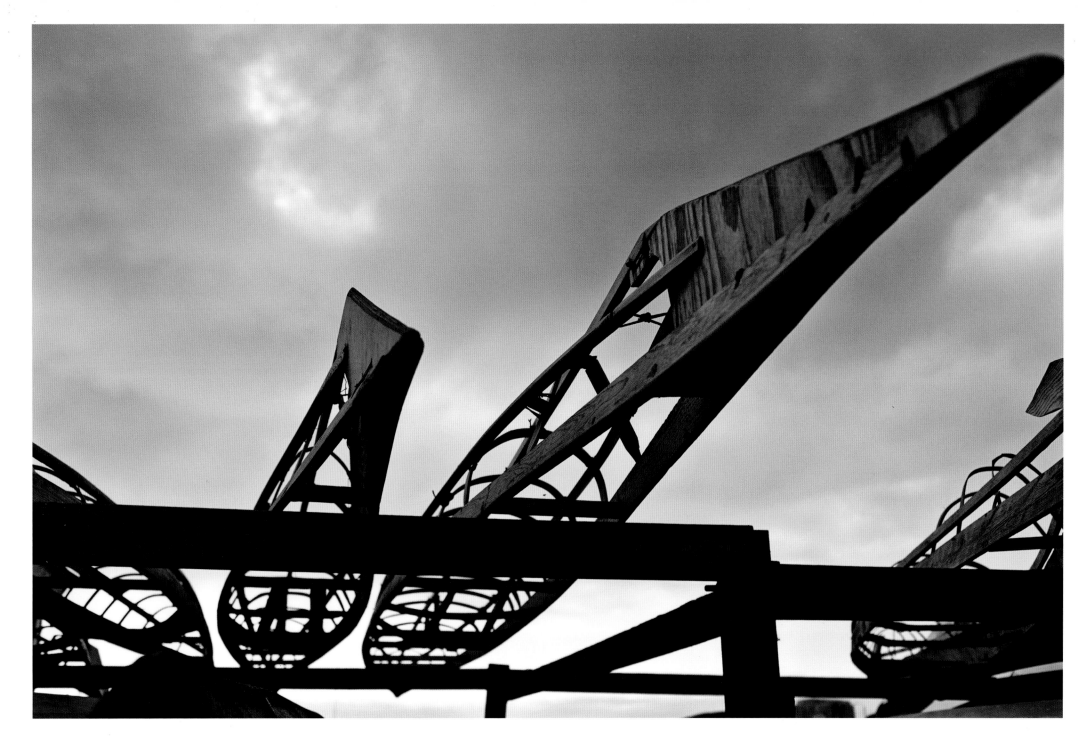

British Snow Cat, Horseshoe Island

Antarctic Peninsula, February 2008

It would seem that no matter where we go or how hard we try, we take who we are wherever we travel. It was a state-of-the-art snow caterpillar back in the 1950s, now it is a slowly rusting relic left behind in a "pristine" environment. It is too costly to take away the equipment and debris, so like Everest it stands as a reminder of who we were once long ago and asks us, who do we want to be moving forward?

overleaf

Esperanza Base, Hope Bay

Antarctica, February, 2010

I only saw the children briefly as they headed to school on the remote Argentine base. I thought how amazing it must be to grow up in Antarctica. I wondered, would these be the children who would make great astronauts? Future explorers of our solar system and beyond? This base is the only station to allow whole families to live in Antarctica year-round; it has two schoolteachers for ten families.

Oil Drums, The Commandante Ferraz Antarctic Station

King George Island, Antarctica, December, 2007

It was a strange day. As we made our way to the Brazilian base we saw bits of debris floating here and there. It had been only a few days since the sinking of the M/V *Explorer* near the South Shetland Islands. Something about that event had put all the crewmembers on edge. Arriving at the Brazilian base brought it home when we saw an empty lifeboat from the *Explorer* adrift in the sea. The oil drums littered in the snow foreshadowed the destruction of the base in a fire in 2012. Antarctica is an unforgiving place.

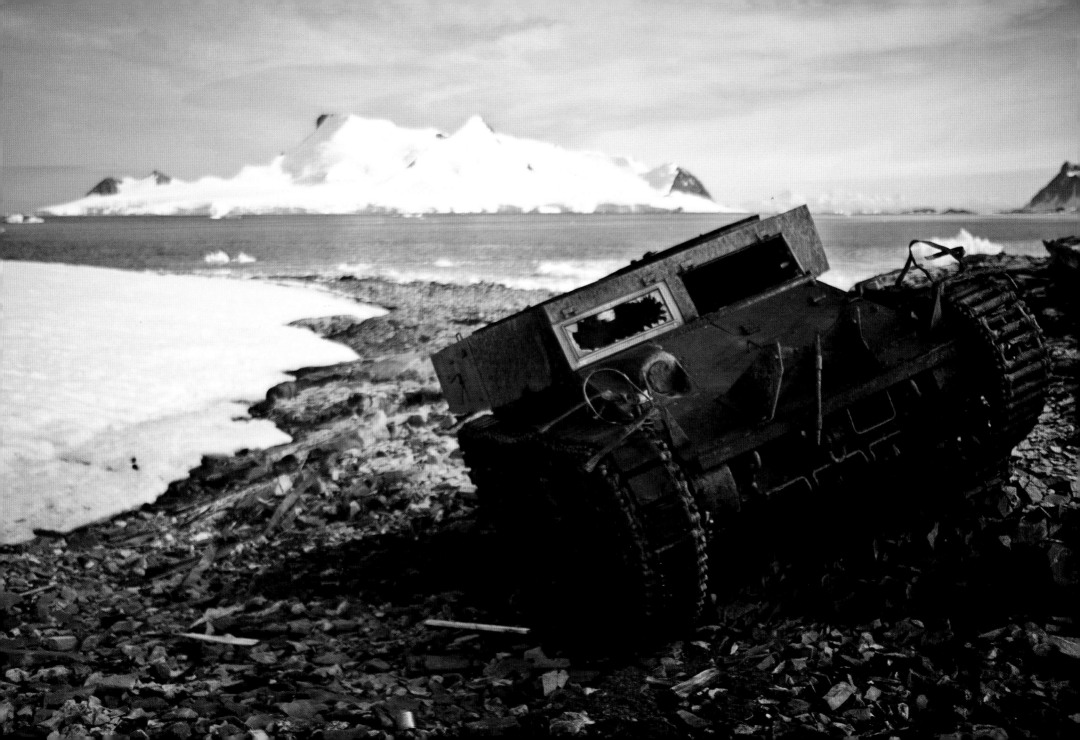

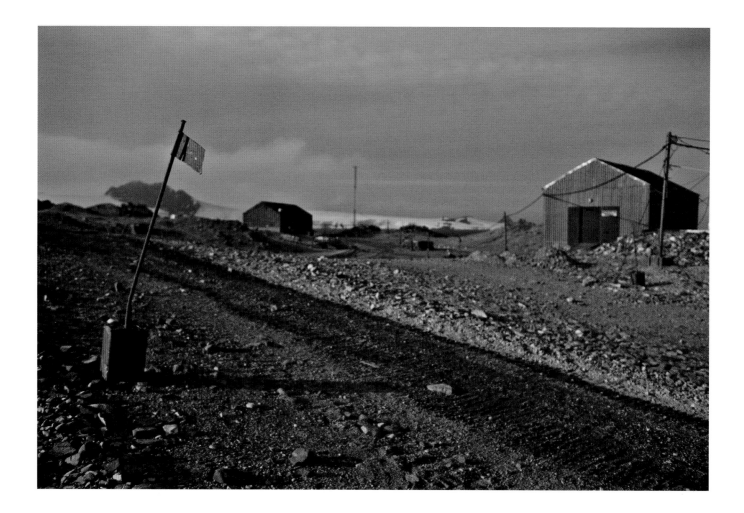

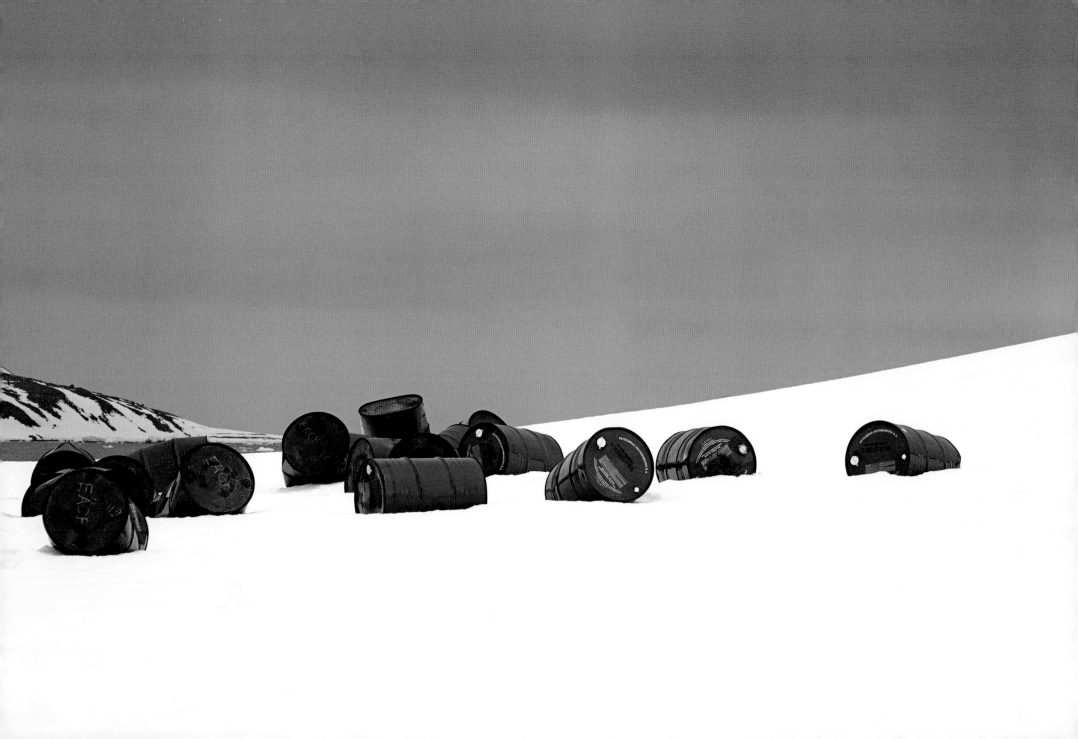

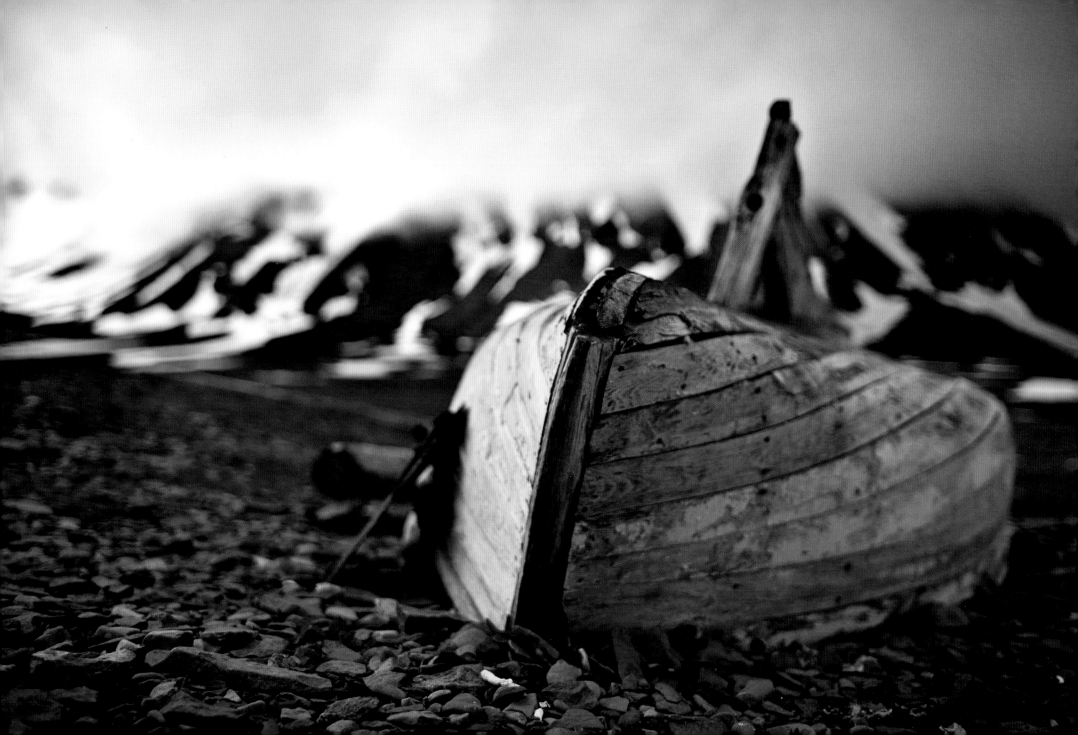

The Things We Did (That We Cannot Forget)

Bamsebu, Van Keulenfjorden, Svalbard, July 2010

Not far from this old overturned whaling boat lies the remains of 550 beluga, or white whales. The Dutch name for this place harkens back to the late seventeenth century publisher in Amsterdam that was known for its nautical charts. Early exploration of the Arctic was driven primarily to discover new whaling grounds. Men who traveled here to work as whalers (as early as 1604) were required to bring their own coffins, as there are no trees on Svalbard. The Dutch ceased whaling in the area after 1770. The British kept at it until the early nineteenth century after the bowhead whales became rare.

overleaf

The Commandante Ferraz Antarctic Station

King George Island, Antarctica, December 2007

Russian Coal Mining Settlement of Barentsburg

Svalbard, 2010

Barentsburg is still a functional coal mining settlement with five-hundred full-time Russian and Ukrainian miners living in Soviet-era dwellings. The miners have been known to run out of food and supplies, which are shipped in from Russia.

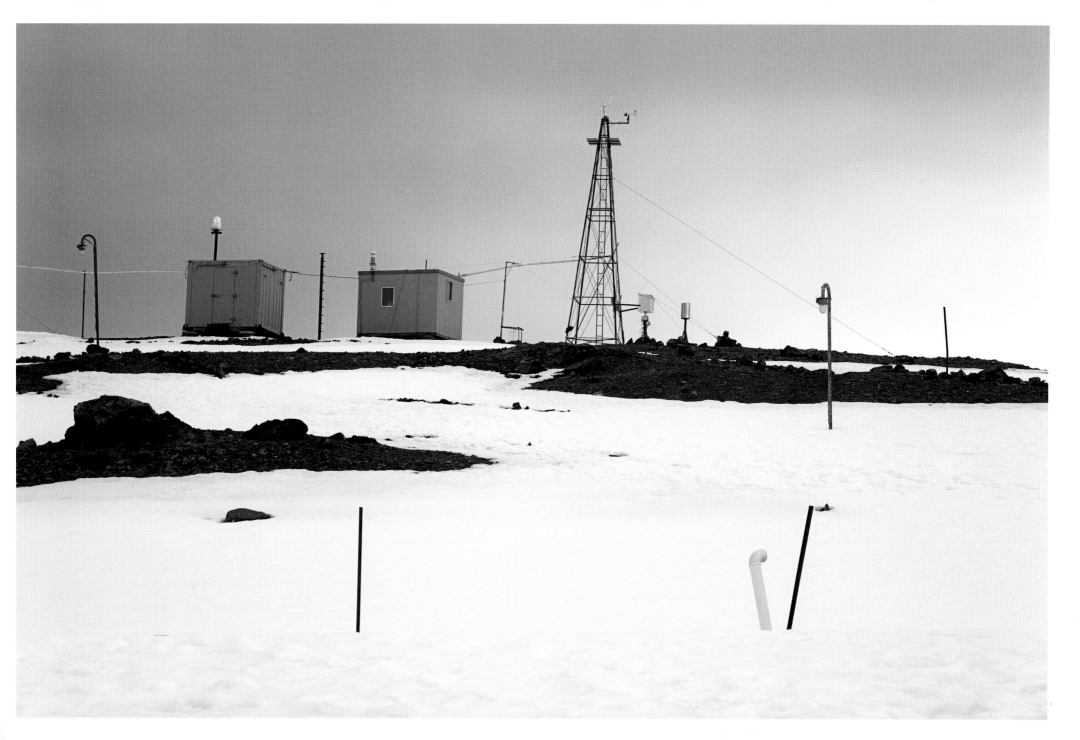

I V

In 1991 I was attacked on a New York City subway. The ordeal left me in need of a change of scenery. The mother of my boyfriend at the time gave me a one-way ticket to San Francisco. I had never been to California before. Something about the quality of light, the brightness, and the warmth of the people was very appealing to me. I took an Amtrak train back to New York and announced that I was moving to the Bay Area.

I had many amazing adventures in California. I learned to surf, I rode vintage Italian scooters and German motorcycles. I held different and varied jobs. I was a baker. I worked in an urban salvage yard. I worked at an architecture firm. I developed images at a one-hour photo lab. Most of my jobs were part-time, allowing me time to work on my traditional beadwork making moccasins, bags, dolls, and clothing, as well as time to surf several days of the week. Out west, I also worked as a hiking and bicycling guide in Glacier National Park, Bryce, Zion, Arches and the Grand Canyon as well as pedaling guests' bottles of wine around the Napa, Sonoma, and Alexander Valleys. In between these jobs, I would travel the Pacific with my surfboard. First to Hawaii, then Baja California, living on the beach at Punta Conejo for a while with my dog. After Mexico, I decided to go to New Zealand and Fiji then Australia. Always on my own with just my surfboard and a camera. Surfing became a magical communion with the ocean. I loved feeling the power of the water. Each day was a special gift. My surfing adventures taught me a great deal. I learned just how capable I was. I saw how similar people were no matter where you went, how beautiful the oceans are.

By the time I was twenty-nine years old, I was doing my beadwork almost ten hours a day, six days a week. I was making a good name for myself, and I had a steady stream of orders from galleries and individuals across the country. One day I woke with my left hand feeling as if it were on fire. I went to the doctor and was diagnosed with DeQuervain's tendonitis. My options for treatment were surgery, steroid shots, or let it rest. I chose rest. I was devastated.

I loved beadwork, making artful and useful objects, using traditional smoked deerskin hides. I couldn't understand why this was being taken away from me.

Since I had little do as my hand healed, my boyfriend invited me to join him on short business trip to Los Angeles. While we sat waiting to board the plane, the airline announced that the flight was oversold. "We are looking for passengers who can wait one hour for the next flight. In exchange for your seat on this flight, we are offering a free round trip ticket anywhere we fly in North America." A free ticket, just for waiting an additional hour? I could do that. So my boyfriend went on without me, and I met up with him a little later.

We were traveling on Alaska Airlines, and before that moment I had no ambition, dream, or desire to see Alaska. Yet here was a free ticket inviting me to do just that. Many children dream of being a polar explorer, visiting Santa Claus at the North Pole, seeing where the polar bears live. Not me. Part of the joy of living in the Bay Area was its stable, moderate climate. Never too cold, never too hot. No real seasons, in fact; rather, a perpetual spring and summer. The idea of going somewhere cold had never excited me, but nonetheless, I decided I would go to Kotzebue. I chose this place because of its location on the Bering Strait well above the Arctic Circle, the home of the supposed Bering Land Bridge. As schoolchildren, we had been taught that during the last ice age the aboriginal peoples of the Americas had made their way from Siberia into the New World across this bridge. I was curious about this and decided I would like to walk across the frozen sea back toward Russia in a sort of reverse commute of my ancestors.

I did a minimal amount of research. I knew only that when I arrived, it would still be quite cold, though technically Spring. I purchased some serious cold weather gear, packed it along with the rest of my stuff in a duffel bag, and off I went. When I landed in Kotzebue, I was presented with a shocking reality of an unfamiliar landscape, absolutely white and still. When I checked my luggage, I was only wearing a polar fleece jacket and slip-on shoes. My SLR

film camera was in my carry-on messenger bag. I was completely unprepared for the freezing air that met me when I stepped off the plane (there was no enclosed jetway). My nose hairs and lungs instantly froze. "Brrr!" I thought, "better go get that North Face jacket!" Half of the plane was dedicated to cargo. Fewer than twenty passengers were in the back of the plane with me, most of whom were native Inupiaq. Inside the Quonset hut that served as *the* airport was a tiny luggage carousel. One by one, passengers gathered their belongings and went off into the bitter cold until I was left alone, watching the miniature carousel go round and round without my bag ever appearing. Two women, both Inupiaq, who worked for the airline took pity on me. "Don't worry," they told me, "We will get you taken care of until your bag arrives." Within a matter of minutes, they had me suited up in sealskin parka, boots, gloves, hat, and even some goggles! One of them called her sister who drove the local taxi, and after giving me an hour-long private tour of the small town (taking me with her as she picked up and dropped off fares), she delivered me to my hotel.

One morning during my stay, I decided that the day had come. Today, I would walk across the Bering Strait. I suited up and headed out—it was negative thirty degrees Fahrenheit, negative fifty with the wind chill. I walked down the snow-covered bank and stepped onto the frozen sea and just started walking. Every part of my body was covered. I wore ski goggles and a scarf wrapped across all exposed parts of my face. I was so well bundled that I could hear my breathing; it felt like I was an astronaut walking on the moon or maybe Darth Vader exploring the Arctic. Surprised at how squeaky the ice was beneath my feet, like Styrofoam, I walked slowly at first, unsure of how far I could trust this unfamiliar surface. I quickly gained confidence and felt reassured when I noticed that someone had placed small twigs in the ice spaced every twenty feet apart. I was walking a primitive path, leading away from the town and toward the strait and the sea. I was walking on the frozen sea, but I may as well have

been on some distant planet. My extraterrestrial moment, only I was right here on Earth! I was so thrilled that I almost didn't notice the young man pull up beside me on his snowmobile.

"You all right?" he asked.

"Oh, yes," I said, "I am just going for a walk."

"Okay," he said. He cocked his head in confusion and rode away.

Several other people pulled alongside me as I walked, always asking the same question, always replying to my response in the same way. After I had walked for over an hour with no traffic, the twigs were no longer visible. Two people rode up on either side of me. On one snowmobile was an Inupiaq man. On my right was a Russian woman. The man asked me a different question than all the others who had stopped previously.

"Where are you going?" he asked, and I replied, "I'm trying to get to where the ice ends and the sea begins."

I really thought there would be a clean edge of ice and suddenly there would be the dark water of the sea. I was so naive and misguided in my thinking. The man told me that was twenty-two miles away. They said they were headed out there to ice fish and I was welcome to ride with them, but they also let me know they would not be coming back. They were planning on camping out on the ice. I thought about it for a moment. I had no supplies on me. No water, no shelter, no food, no extra clothing. Nothing. Just my camera tucked snugly in the warmth of my parka. I knew I had no realistic expectation to actually reach Russia, and certainly, they would not permit me entrance even if I did make it that far. "Well," I thought to myself, "I have never been on a snowmobile before." Here was an interesting opportunity. I told them I would ride with them for a short while and climbed on the back of the man's machine. I quickly realized that these machines go fast! We were going sixty miles an hour. As we were zipping along the ice, I began to realize that this speed meant distance. I did some math in my head, sixty miles an hour divided by five minutes. I tapped

the man on the shoulder, "Stop! Stop!" I said. "I have to walk this back." They stopped, let me off, and I thanked them. Watching them ride toward the horizon, I took a photograph of their backs as they drove away.

At that time of year, the sun hangs low in the sky just above the horizon. It never climbs high in the sky and so it seems to move sideways. Around one in the morning it dips below the horizon and then climbs back up two hours later. Though it's never very bright, it is a beautiful thing to watch the sun move sideways.

After the snowmobilers were out of sight, I turned to look for the town. I scanned the horizon and could not find it. The town was gone. All around me 360 degrees of just white, just white, with hardly any difference between the sky and the ice. I freaked out. I realized that no one in the entire world knew where I was. All of the realities of my situation became clear in my mind: I was on the frozen sea. I could fall through the ice. There were polar bears out here. There could be a whiteout and I would never find my way back. If it got much colder, I could freeze to death. I had no food or water. What was I thinking? I tried to calm myself and decided to follow the tracks of the snowmobiles back before the wind wiped them away.

During the five plus hour walk back, I had an awakening. Everything that my grandfather had been trying to show me when I was a child was confirmed. In this extreme part of the world, I *clearly* understood that I am a creature of this planet. I am literally made of the material of this planet; we all are. As I walked the many squeaky steps across those white miles, I realized the absurdity of religion, of border, of culture and language. At the bottom of it all, we are all made of the same material. We are all earthlings. There is no separation. There is no distinction. None of us was born in outer space; we will all return to the material of this Earth. I understood that I was standing on *my* rock in space. I understood the immensity and the minuscule nature of that. I understood that I meant nothing in the scale of time and space and history of this planet. If I were to die, snow and ice would blow over my cold dead body without a thought, but the fact that I was still alive, standing on the ice and pondering such things was a miracle. I began to think…if my sweat becomes the rain, whose sweat is this ice? How many ancestors ago? What creatures created this? They are all my relations, all my relatives, and in that I understood the integral nature of this planet. We truly are a web of life, each connected to the other. I began to see how absurdly we as humans are presently acting and thinking. We are behaving as if we are somehow separate or above all other life forms on this planet, thinking we can do whatever we want. How silly we are to be surprised at the consequences of such practices. I was a different person when I climbed up the bank and walked back toward the Nullagvik Hotel.

What I did not know at the time was that as I made that walk out onto the frozen sea I was actually a few weeks pregnant with my daughter. I realize now that as I awakened to this new perspective, my child was growing in me. She has been with me through this journey. I awakened as a mother.

Gentoo Penguins at Port Lockroy

Antarctic Peninsula, December 2005

Port Lockroy was established as a British base during World War Two. It was in operation until 1962. The islet that it is situated on is so small that you can walk around it in less than ten minutes. Gentoo penguins nest there. There is no plumbing or heat at the station, which is now a museum. Port Lockroy has the greatest number of visitors each year, more than anywhere else in Antarctica. It must be because of its awesome gift shop and post office.

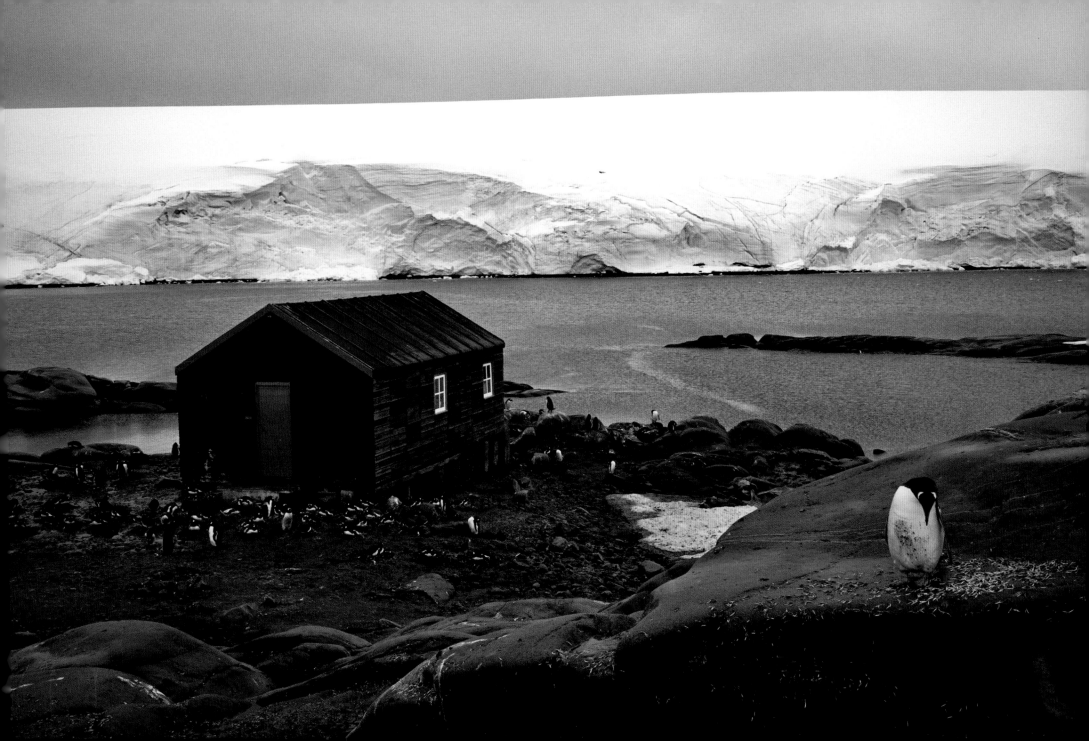

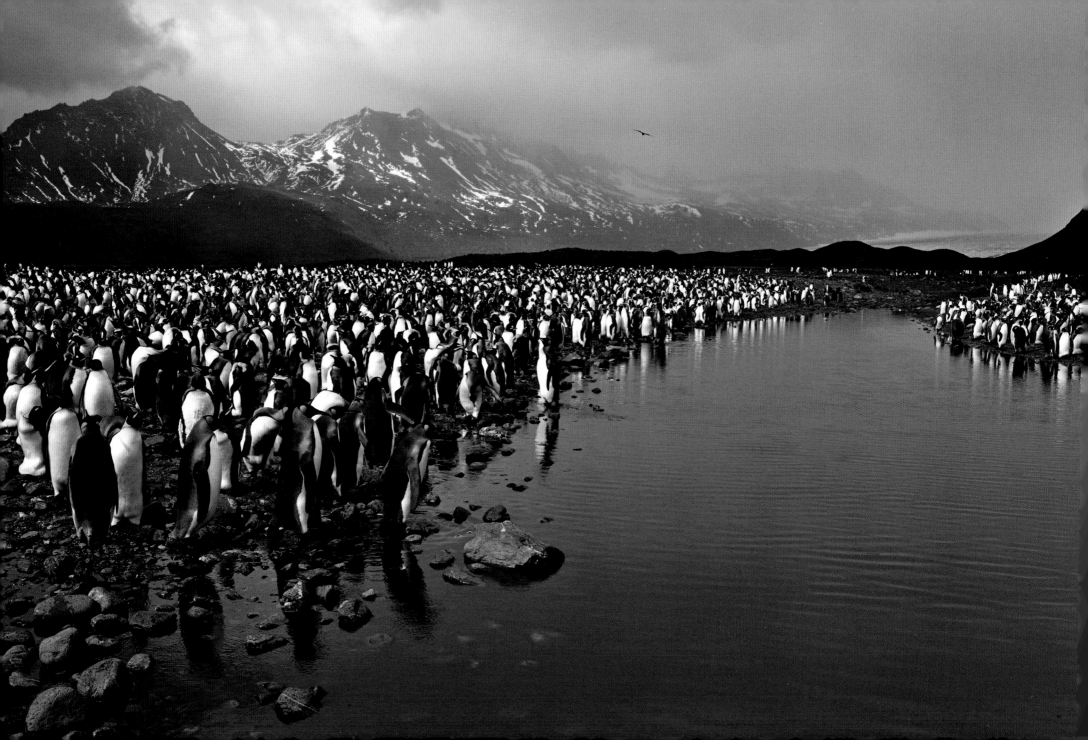

The Kings of South Georgia

South Georgia, March 2010

There are few scenes on this planet that can rival the accumulated mass of king penguins on South Georgia. Landing here is like arriving on some strange planet that time has forgotten. The king penguins are the second largest species of penguins.

Reindeer over the Kings of South Georgia

South Georgia, March 2010

In the whaling days of South Georgia, the Norwegians brought
reindeer with them as a food supply. Now, a hundred years later, those
reindeer remain. Seeing reindeer and penguins together makes for
a strange scene.

overleaf

Gentoo Penguin Courtship Pose

Cuverville Island, Antarctica Peninsula, December 2007

These two gentoo penguins are doing a courtship dance. They must
move in perfect synchronicity if they are to choose to stay together.
Pairs may stay together for many years and restrengthen their bond
by doing this dance.

Adélie Penguin Remains

Cape Bird, Antarctica, December 2006

The remains of this penguin may be two hundred years old. It was
buried and dried under during a centuries-old blizzard which
overcame the majority of the penguins nesting there.

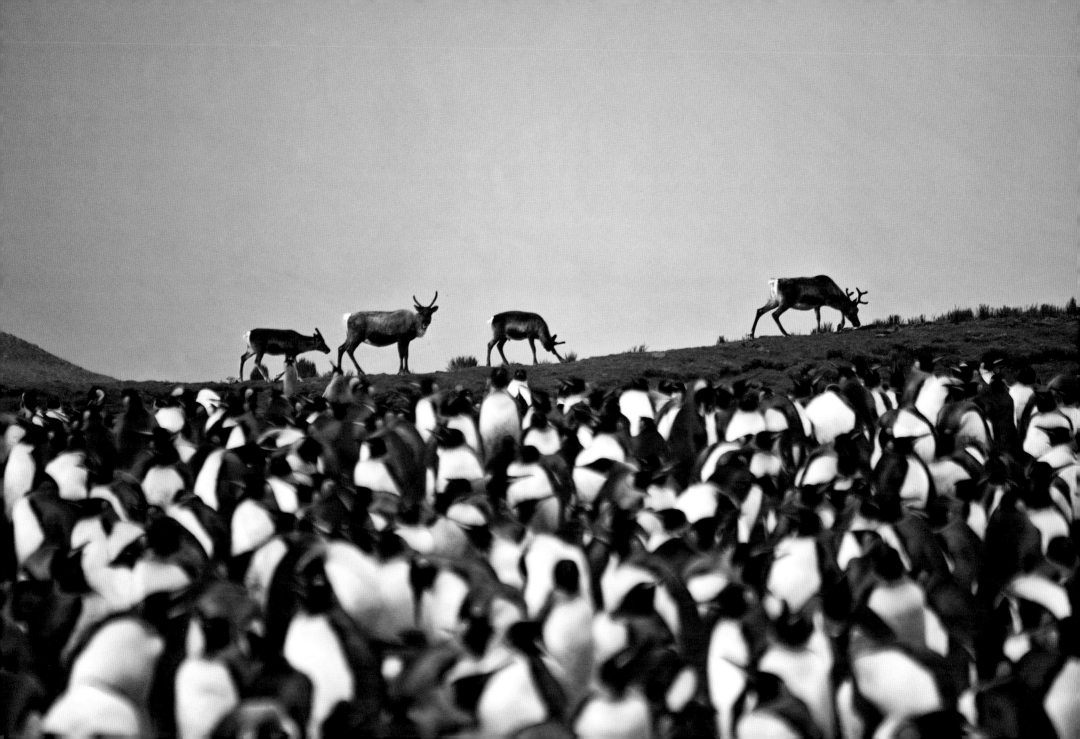

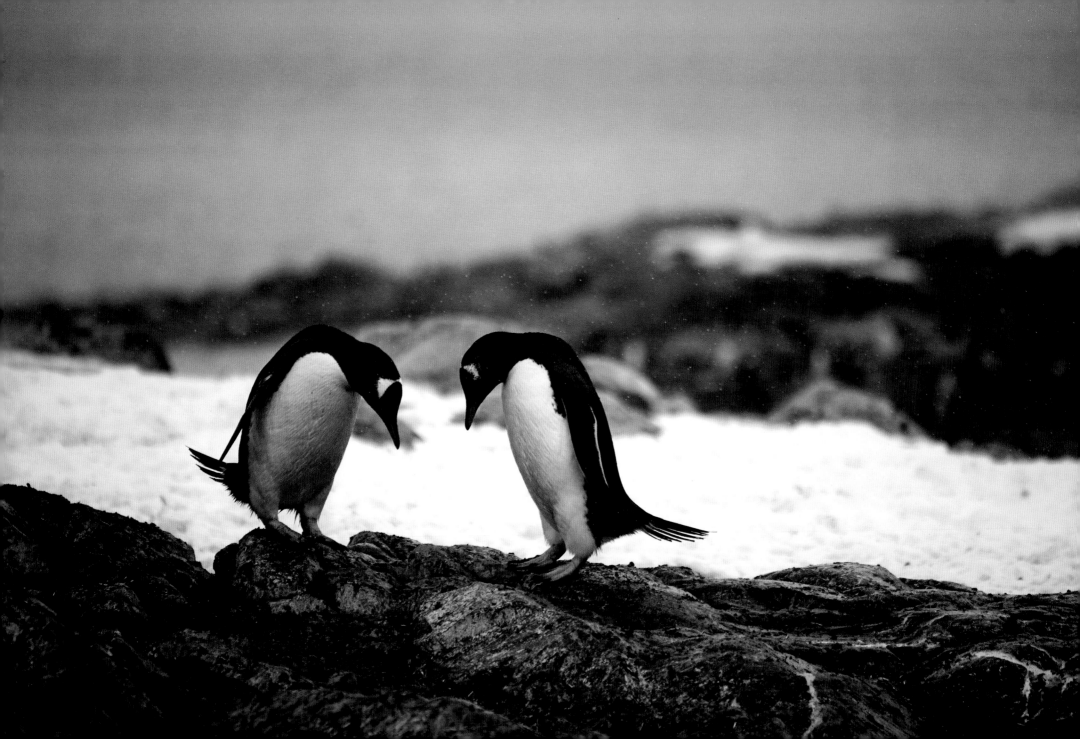

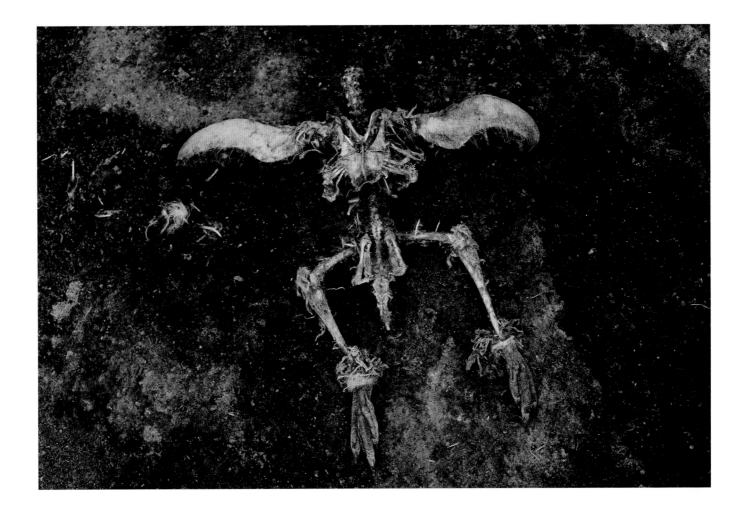

You Go First

The Ross Sea, Antarctica, December 2006

Orcas were patrolling the sea ice edge. The Adélie penguins seemed
to be having a conversation, which I imagined went something like this,
"You go first! I went first the last time!"

overleaf

Spoiled Adélie Penguin Egg

Cape Bird, Antarctica, December 2006

It takes the skill and diligence of an experienced parent to fend off the
constant attacks of a relentless skua. Even skuas have mouths to feed.

Adélie Penguin Colony Detail

Cape Bird, Antarctica, December 2006

Studies have shown that penguins return to roost within one meter
of where they were hatched, therby turning rookeries into ancestral
neighborhoods. Adélie penguins build their nests out of small rocks
and pebbles, some of which are stolen from their neighbors' nests.

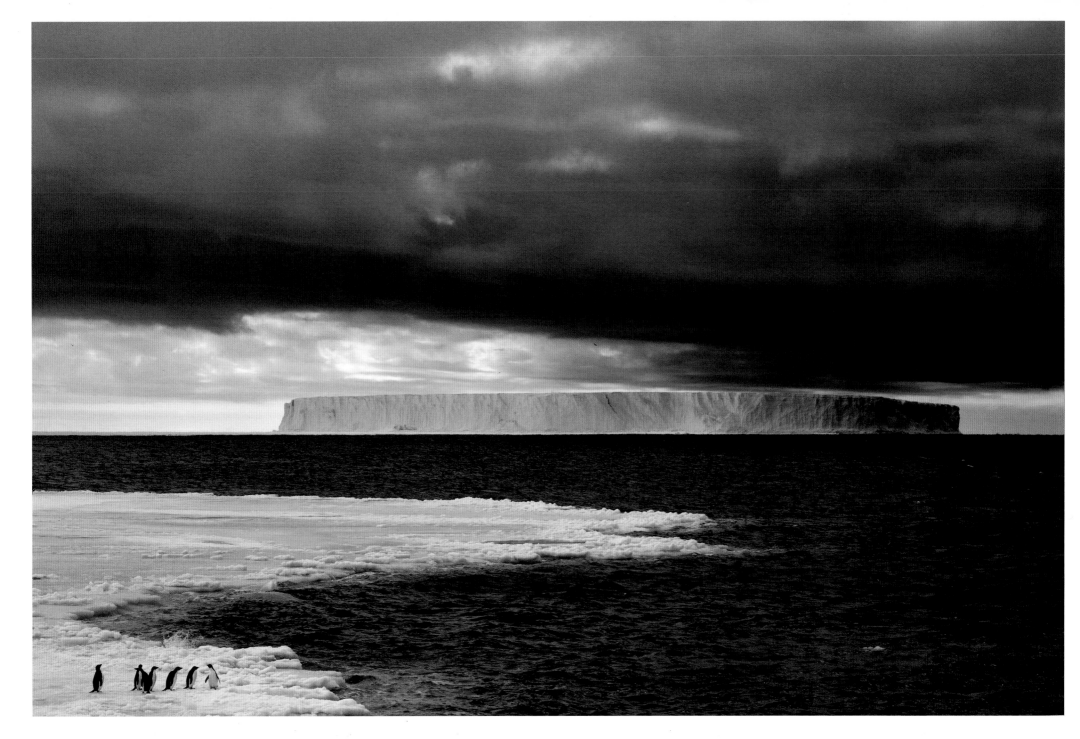

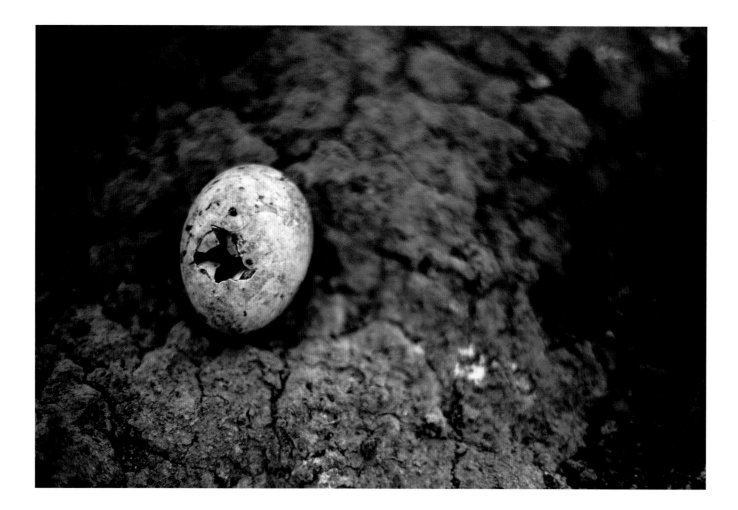

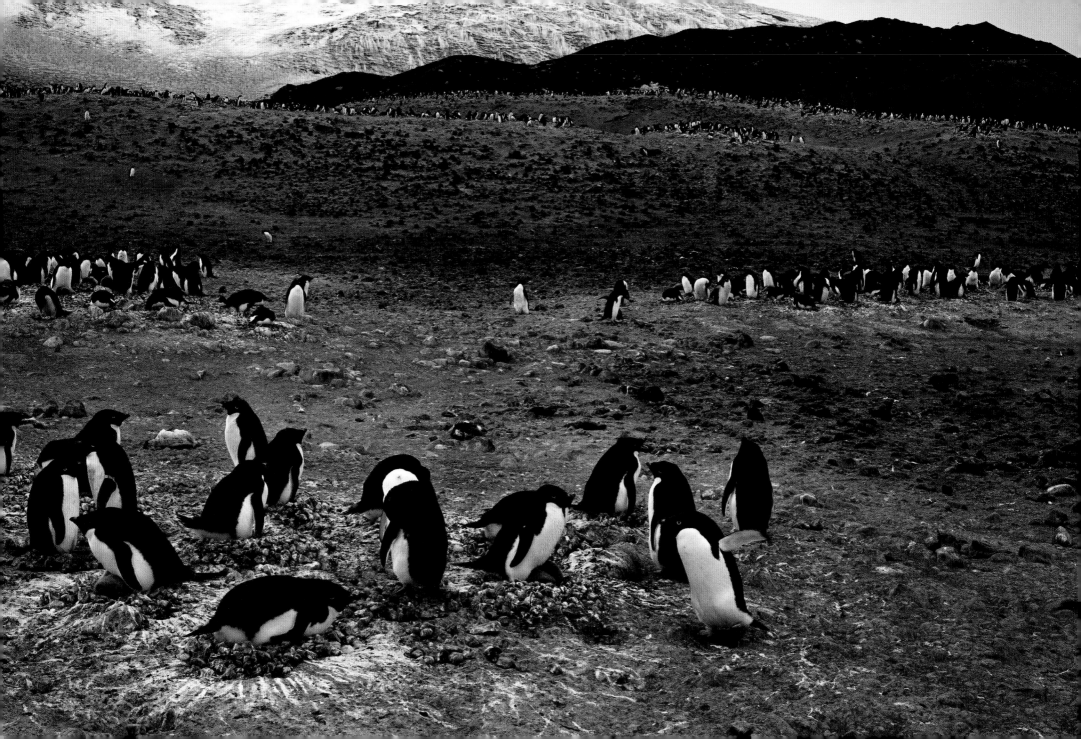

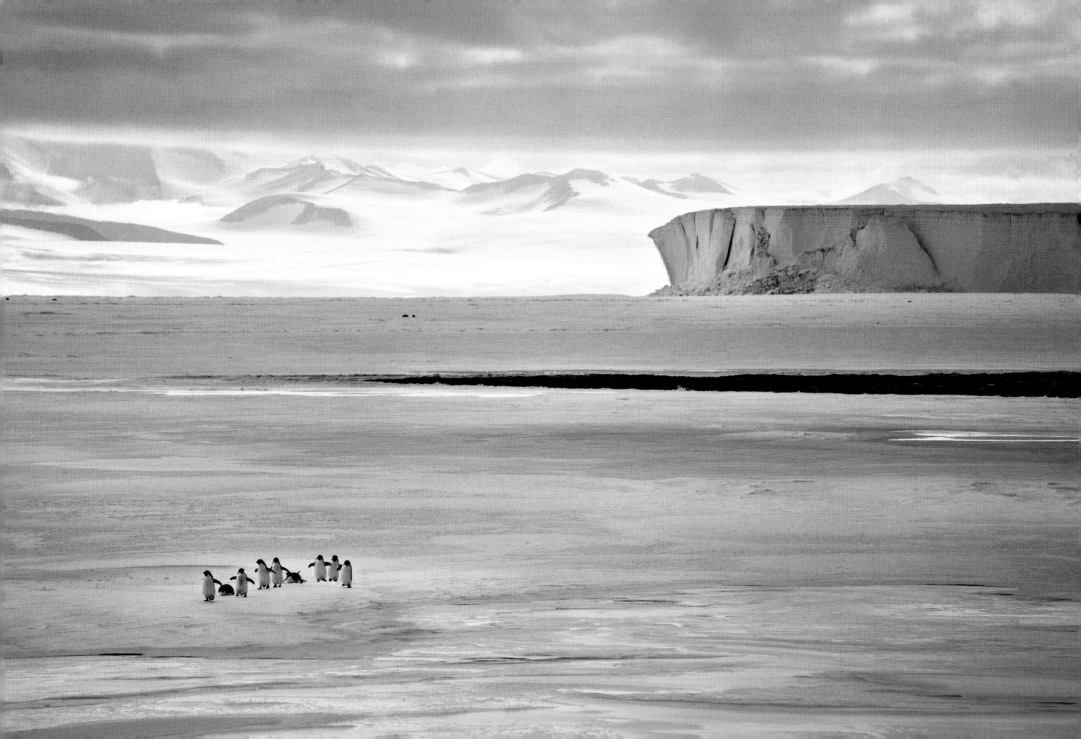

Running to See

Ross Sea, Antarctica, December 2006

I watched the penguins travel across the ice for hours. They would waddle and fall, waddle and slide, and little by little they came all the way over to see our massive ship wedged in the sea ice. They looked at us by turning their heads first to the left, then to the right. After thirty minutes of them looking at us and us looking at them, the penguins decided they still didn't know what we were or why we were there. They turned around and began their long journey back to their home.

overleaf

Gentoo Penguins in Snow II

Port Lockroy, Antarctic Peninsula, December 2007

Historically speaking, Antarctica is a dry place, and precipitation is not as common as one might think. Penguins have never developed the instinct to abandon their nests if they are buried in snow. Unfortunately, snow is more common in now, and penguins can actually be buried alive under snowfall.

They Walk in Line

Franklin Island, Antarctica, December 21, 2006

If you spend even just a day observing penguins, you will grow to have the utmost respect and regard for them. They are humorous characters with an amazing work ethic and sense of tidiness. These Adélie penguins are on their way to the sea for a daily bath and to perhaps find some food.

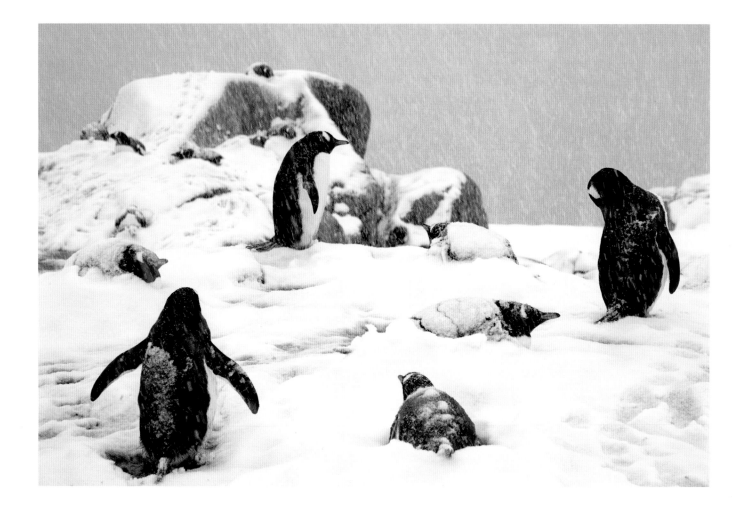

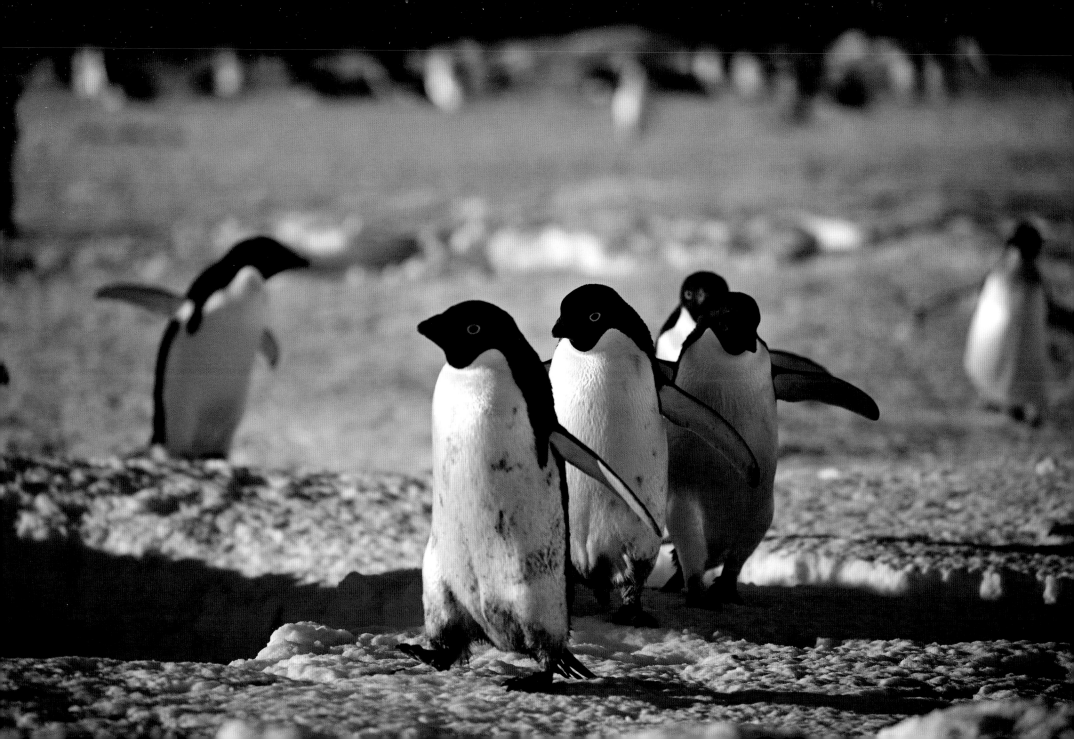

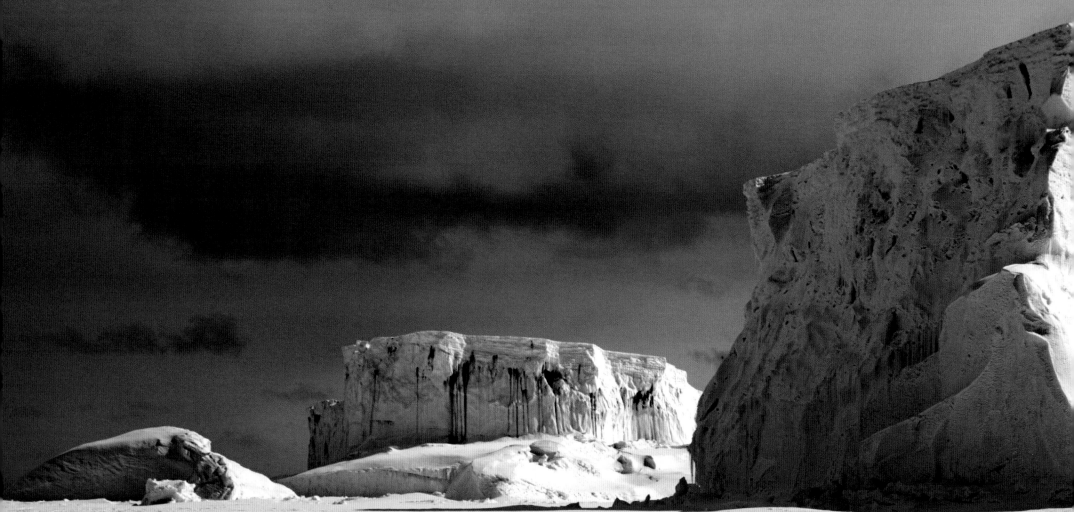

Lone Emperor with Icebergs

Cape Washington, Antarctica, December 2006

Emperor penguins leave sentinels like this one behind as babysitters while the majority go off to feed and bathe themselves. When we arrived at Cape Washington, I was excited by the drama of the landscape. Massive icebergs frozen into the sea ice created the realm in which hundreds of emperor penguin chicks were huddled into small groups. It looked like a scene from a movie. While we were not permitted to approach any closer than fifteen feet, the penguins could come as close as they liked to us. I found that just lying down on my belly in the snow encouraged trust, and both young and adult emperors would walk within inches of me.

overleaf

Iceberg Pointing Up

Greenland, September 2009

As we were sailing through the Disko Bay, a lone iceberg would appear every now and then. I remain amazed at the individuality of each berg, the shape, the color, and even the way each moves through the dark, cold waters.

Gentoo with Glacier

Port Lockroy Antarctic Peninsula, December 2007

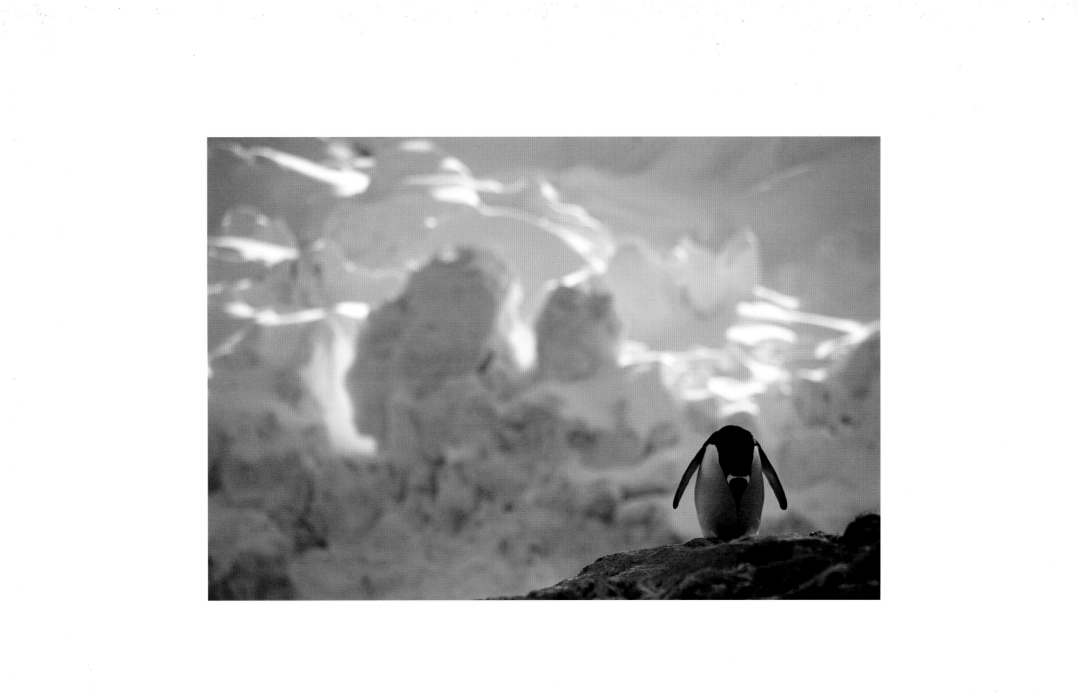

V

When Kathan, my boyfriend's mother, heard me tell my story of walking on the ice and meeting my planet, she decided she had to go to the ice and see for herself. Kathan was almost seventy years old when she boarded the Russian nuclear-powered icebreaker I/B *Yamal* bound for the geographical north pole. When she returned, she told us her journey was so affecting that she wanted to write a book about her experience. Kathan wanted to include me in the book, because I had been the inspiration. "We all have to go to this place called Svalbard," she said. I remember thinking that I did not need to be as cold as I had been in Alaska ever again. I was really hesitant, but Kathan is persuasive. She is an incredibly inspiring, powerful, and impressive woman. So we went.

By this time my daughter had been born, and 9/11 had occurred. I was holding my child in my arms as I sat watching the towers fall, and I understood in that moment that my daughter would never know those buildings in the way I had. That knowledge triggered something. Years before, when I was a bike messenger, I used to deliver parcels there daily. The World Trade Center was part of my visual landscape. I knew those buildings, I knew that space as a community of people. When they fell, it was the first time I realized the significance of a photograph as a historic document, as memory—nonexclusive memory, a memory that might be shared with others, even those as yet unborn. A photograph, of the towers, of a face, of an iceberg, is proof of existence, much in the same way photos of our ancestors are.

The second electric moment that convinced me to think of myself as a photographer occurred when the United States was target bombing Afghanistan. I remember sitting on my couch in North Berkeley watching the news and thinking that we, as a people, as a country, were going the wrong way. I knew another story must be told, the story of how beautiful life is and how amazing this planet is and how lucky we are to have what we have. The switch

had been flipped. I knew with great clarity and certainty that I would use a camera to document my experiences and aim to tell a different story than the one so prominent on the evening news.

When Kathan took us to Svalbard, I was now a *photographer* with intent and purpose. I had different formats of cameras with me—a 35 mm rangefinder, an old Rolleiflex TLR, a 4 x 5 field camera, and a 6 x 4.5 medium format camera—but I had no master plan. I only knew I was going to make photographs.

The trip to Svalbard was quite different from my solo adventure to Alaska almost four years earlier. This time, I was with my boyfriend, his mother, and my daughter, already three years old. We flew to Longyearbyen, where we boarded M/V *Polar Star*, a small Norwegian ice-strengthened ship that carried fewer than sixty paid passengers, all interested in seeing the Arctic and maybe some polar bears. As the *Polar Star* sailed north, we headed into drift ice and I fell in love. There was something so strange yet so wonderful about the sensation of our ship breaking through the ice. Part of my brain was thinking ice plus ship equals bad, but it was magical to watch my daughter's expression as the ship bumped and scraped and ground through the ice. We all loved it. As a thank you for taking us to Svalbard, my boyfriend and I decided to take Kathan to Antarctica for Christmas the following year. My daughter was five as we journeyed across the Drake Passage in the same Norwegian ship.

In August of 2004, after my first trip to Svalbard I traveled to Tibet with *National Geographic* photographer Steve McCurry. When I had decided to become a photographer, I knew I had no interest in going back to school in order to learn how to make it as a professional photographer. Instead, I spent a great deal of time looking at other photographers' work. Whenever I came across someone who was doing something that I wanted to understand, I would contact that photographer directly and ask questions. I admired McCurry's work because he used natural available light and made soulful

portraits of people around the world. That first time in Tibet, I was carrying those five different camera formats, and Steve really let me have it. "What are you doing carting around all that junk?" he scolded. When the sun was high and he saw me out on the streets with my camera, he would shout, "What the hell are you doing out there in *that* light?" He was harsh with me but also very giving and generous. He would pull me into the side streets and alleys, show me where the light was truly magical. There he would take the time to show me how light translated. Steve reminded me that being aware of the quality of light is what made the difference in an image. Traveling through Tibet with Steve was all about making portraits. It was fantastic and I learned a great deal.

However, when I arrived in Antarctica (a few months after my trip with Steve) there were no people to photograph, so I decided to photograph everything as if I were making a portrait. That simple intention resonated with my grandfather's teaching (see a tree as a individual). It worked perfectly. Every penguin that I saw was a unique individual, every hut, every rock, every piece of ice. I could connect with each because each had its own personality.

We were sailing in the Weddell Sea, and there I saw my first giant tabular iceberg, the size of a Manhattan city block. Our courageous Norwegian captain would sail the *Polar Star* between the icebergs. We were inside these canyon-like ice walls that towered 200 to 250 feet above the sea. Some even had their own waterfalls. Glowing neon blue bands around the water's edge of the icebergs hinted of what lay below—another thousand feet of ice. The first time I saw them, my body shook as my mind short-circuited. I was thinking, "How much time is this? How many snowflakes? How many ancestors?" I was so full of wonder and awe. I pondered the sequence of events that had occurred in order to place me there in front of those giants. I felt so privileged to have the honor to witness these creatures as the ice of generations made its way back to the sea.

In 2006, at the Eddie Adams Barnstorm Workshop, photographer David Guttenfelder, without my knowledge, placed my portfolio of the images from my Antarctic and Arctic trips into the hands of *National Geographic* editor David Griffin. I was both thrilled and stunned when David presented me with a check and a National Geographic award for my work. That award earned me a place on the I/B *Kapitan Klebnikov*, a Russian icebreaker, in December of that year. I sailed on a monthlong expedition that left from Littleton, New Zealand, and made its way across the great Southern Ocean into the Ross Sea. The mood of the crew in this part of Antarctica felt much more somber. This voyage was deadly serious. We were going where evacuation and rescue would not be easy, if even possible. Two days into the crossing of the Southern Ocean, one of the passengers informed the captain that he had injured himself horseback riding before we left New Zealand. He was feeling numbness, and disturbed by the movements of the ship, he bagan to wonder if he might have broken his neck. This was serious. We anchored off of a wind-torn Enderby Island, just about the furthest point where Australian Coast Guard helicopters might be able to carry out an evacuation of a passenger. There was no certainty that the helicopters could carry enough fuel to reach Enderby although there were some drums of fuel stored on the island for emergencies. They would also need some of the helicopter fuel we had on *Klebnikov* for our two old Russian birds. The Coast Guard was so uncertain as to whether it could reach us that it sent two helicopters in case one went down on the way to or from the rescue mission. It was exciting, but it was also an intense wake-up call to all of us not to get ourselves into any trouble. In the end, the two helicopters arrived at Enderby and evacuated the man and his wife safely.

On that trip into the south, I was met with twenty-four hours of daylight, and every day revealed a new sort of magic. On board there were fifty paying passengers from all over the world and a dedicated expedition crew. There were ornithologists, marine biologists, and geologists, as well as

a climatologist. There was also an expedition photographer whose name was Pavel Ovchinnikov. He was a warm young man with a great personality who seemed to love photography as much as I did. Many times during the expedition he would ask me technical questions about photography. At the end of the day, many of us would gather around the tables in the dining hall and look over the images we had made. I was happy to share what I knew with those who had questions about their cameras or about photography in general. At the end of the journey as we made our way toward Hobart, Pavel approached me. He handed me the card for the company that had placed him as the photographer on the ship and said, "You know, you would be really good at this."

That was how it began. At first I was an expedition photographer on Russian ships in Antarctica, then Norwegian ships in the Arctic and Antarctic. I would spend one to three months in Antarctica, came home, and then set off for a season in the Arctic. Like I mentioned earlier, I liked to tell everyone I was "bi-polar."

Terminus

Antarctic Peninsula, February 2010

One of my favorite activities at a glacier's edge is to slowly cruise along and photograph the terminus of the ice. It is exciting to be at the point where the ice will calve into the dark water and begin its transformation into something new.

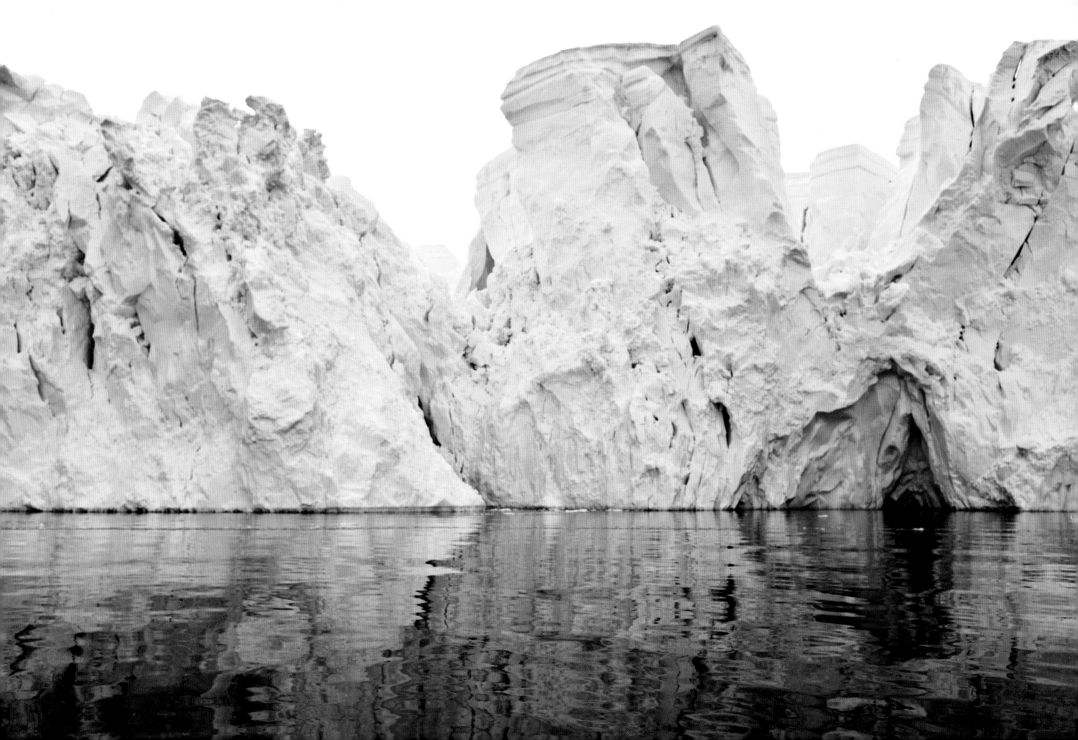

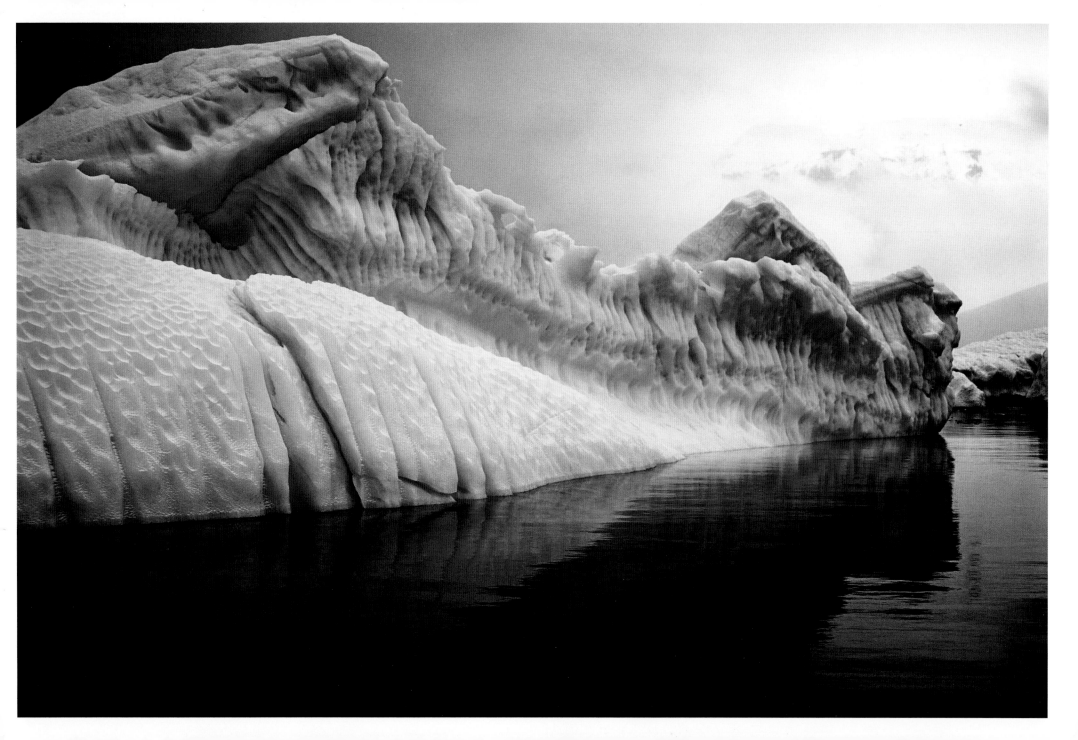

Sun-Dimpled Iceberg in Errera Channel

Antarctic Peninsula, December 2007

A single drop of water acts as a magnifying lens on the surface of this iceberg, encouraging golf ball dimple shapes as the liquid water melts the ice it rests on. And so it goes, drop by drop, melting encouraging more melting until the iceberg slowly disintegrates over time.

Bergy Bits in Errera Channel

Antarctic Peninsula, December 2007

"Bergy bits" are small icebergs that may be no larger than a house. These three bergy bits, jammed like parked cars next to each other, display the variety of shapes and personality that an iceberg can possess.

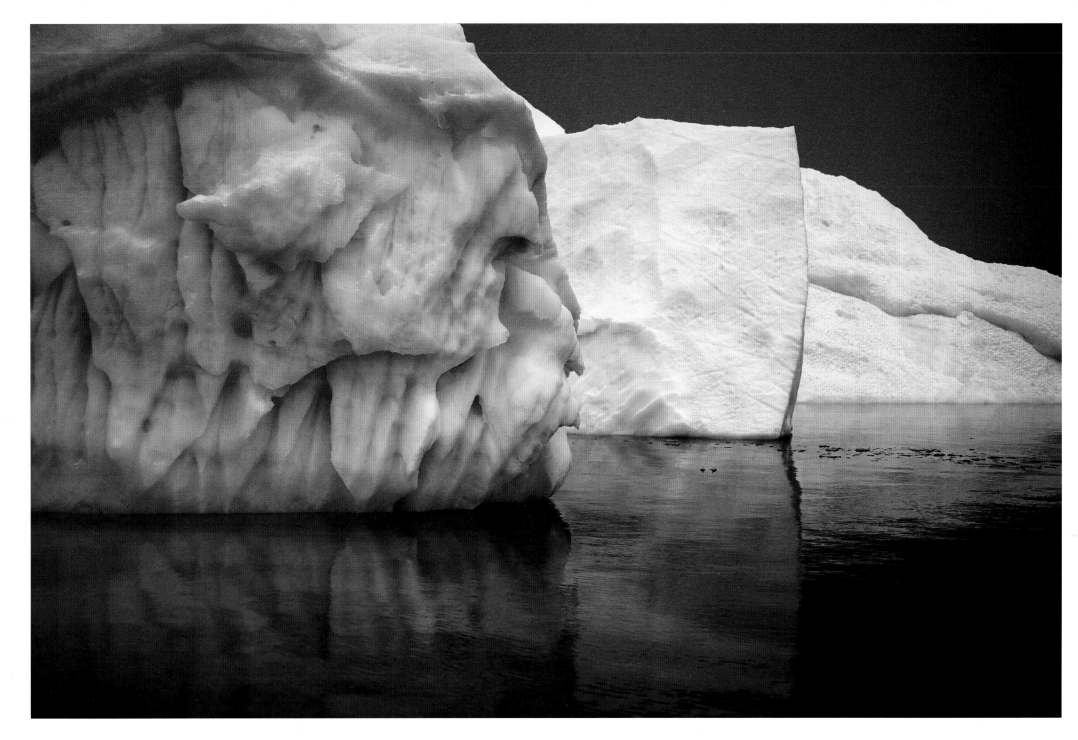

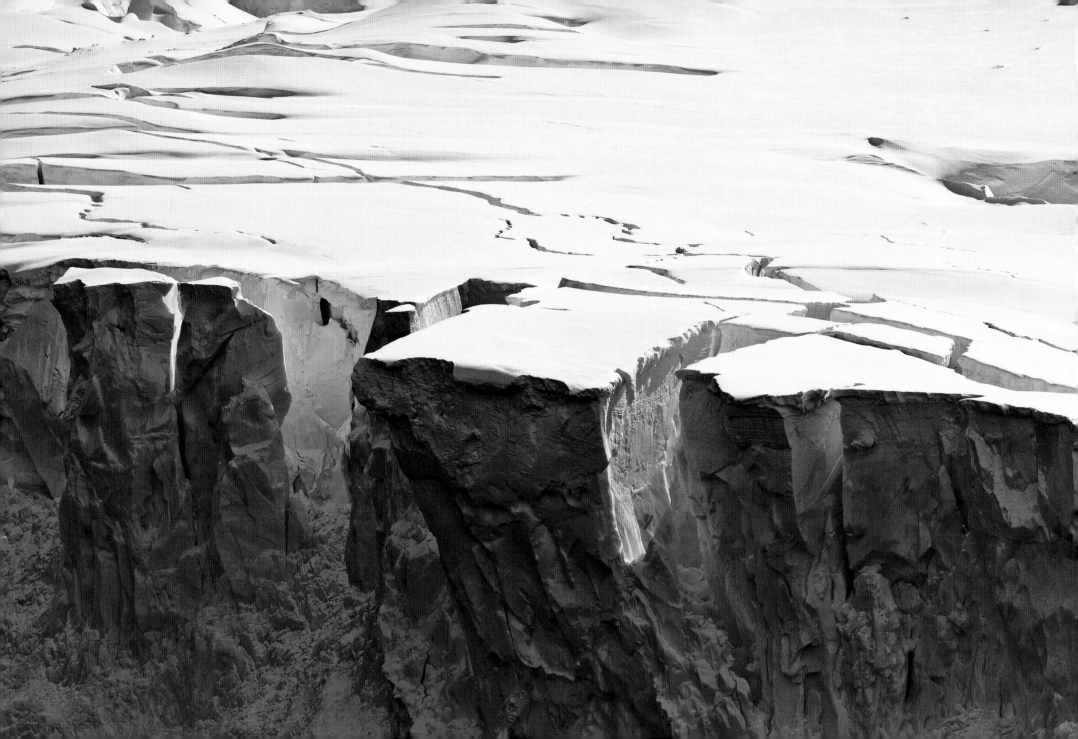

Terminus, Neko Harbor

Antarctic Peninsula, Antarctica, December 2007

All things lead toward their end. I am sure that the massive edge
of this glacier has long since fallen into the sea, returning to the great
cycle from whence it came. Just like it is for us, there is no real end
for the glacier, only eternal recycling. The water that once fell as snow
that then over the millennia was compressed into steel-hard ice that
scraped and bumped along the terrain, sculpting the land as it was
heaved along under its own mass until it reached this edge. Perhaps it
will live briefly as an iceberg, but in any case it won't be long until
it finds itself as rain or snow and perhaps ice once again sometime in
the future.

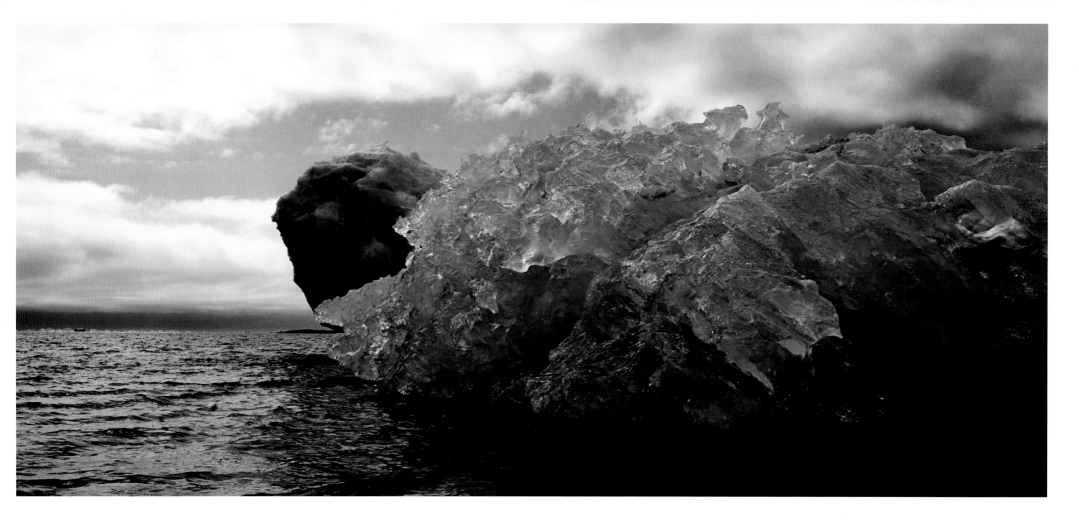

Overturned Iceberg

Qassiarsuk, southern Greenland, August 2008

Before my very eyes, an ordinary looking snowy white iceberg suddenly shifted and rolled to reveal this giant blue snow cone. Blue ice is caused by compression. The fewer air bubbles in the ice, the more blue the ice color, as a result of refraction.

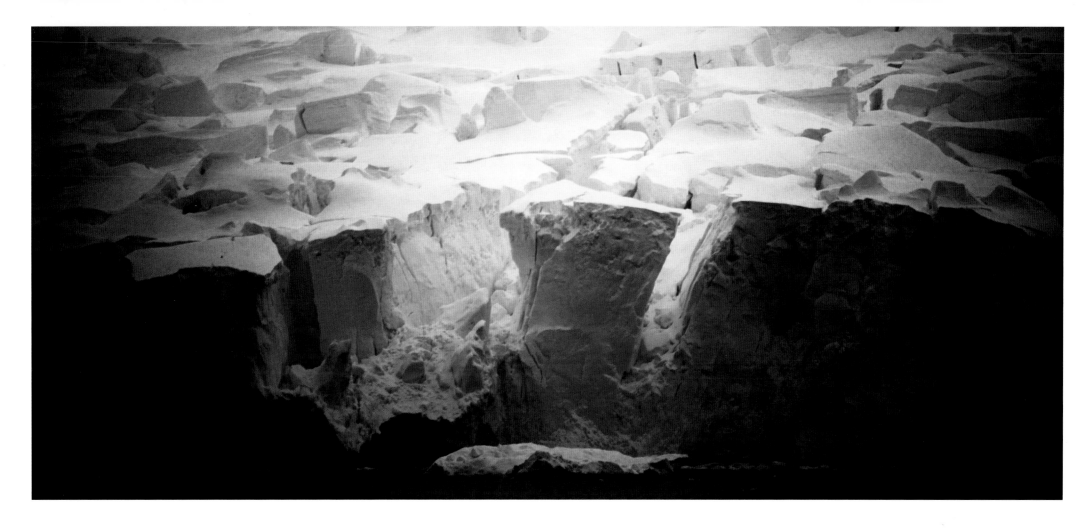

Death is Not the End

Antarctic Sound, Antarctica, February 2010

Storms darkened the day as we passed by this precarious column ofice balanced on the edge of the sea. I could not help but wonder how many years the ice and snow had traveled to end up perched on the edge of its own oblivion.

Blue Underside Revealed Detail II

Svalbard, July 2010

In Svalbard at Kongsfjord Glacier, icebergs calve into lovely turquoise
blue objects. I was fortunate to be in the Zodiac to take this photo
on a cloudy, still day. It's on overcast days that icebergs show their
true colors.

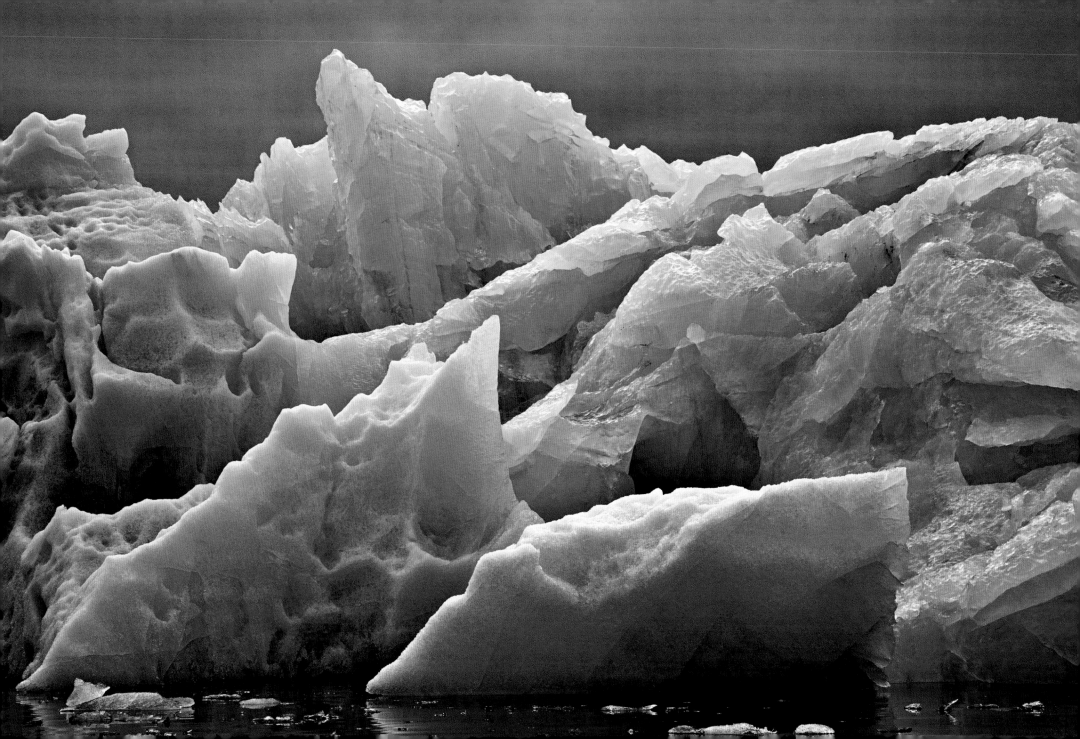

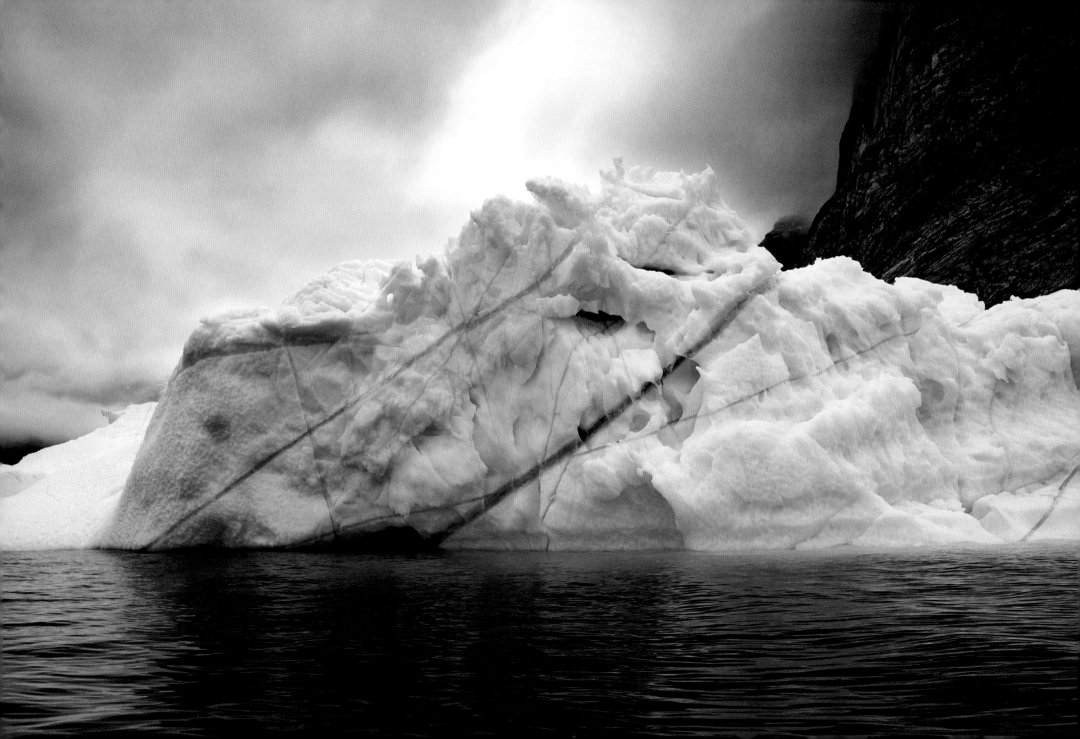

Trapped Iceberg

Eastern Greenland, August 2006

The dark-blue stripe of ice that cuts across this iceberg tells a story of a time when a channel of water flowed through the iceberg and then quickly froze.

Stuck Under the Moon

Disko Bay, Greenland, September 2009

At the foot of the Jacobshavn Fjord in Ilulissat, there is a sandbar.
This sandbar acts as a traffic gate for the fjord. The icebergs have
traveled sixty miles down the fjord—a journey that has taken two
years. These massive icebergs stand well over 250–300 feet above
the waterline. They will stay there, jammed up, until the tide sets them
free. Most likely they will collide and crumble and roll, becoming
smaller before they achieve a green signal to float away.

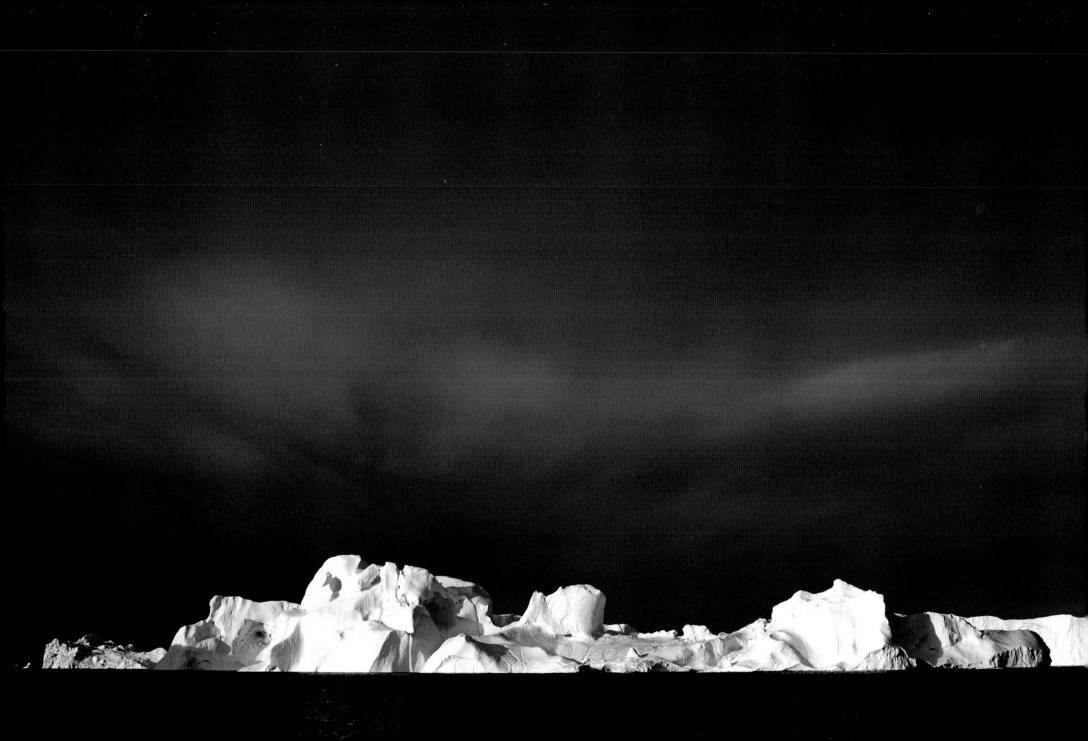

VI

It was not until I was working on ships that I finally felt my last name suited me. One day I was on the bridge of the M/V *Prince Albert II* when the captain addressed me, "Seaman. Is that really your last name?" When I told him that indeed it was and about the seafaring nature of my tribe, he responded with a nod. "That's pretty cool," he said.

For the five years that I worked as expedition photographer on ships, I chased the midnight sun and loved every second of every day. I spent so much time in the polar regions that when I would come home, familiar things would seem alien to me. I spent months in an environment where nothing disturbed the horizon. There were no trees. Then, when I returned to the lower latitudes, I would find myself fascinated by trees. They were so green, so tall. Another thing that interested me was how my extended time in daylight altered how I felt about night. Spending months in regions with no darkness and no stars was quite special, but when I would return home after an expedition and the sky would darken, I would grow instantly anxious. The sky has gone dark! How does this happen? Where did the sun go? Is everything okay?

In 2007 the United Nations announced that climate change was a reality. That same year I mustered the courage to show my images at a juried portfolio review in Santa Fe, New Mexico. The work was received well. I showed many images that I had made in the Arctic and Antarctic. The photographs ranged from landscapes, penguins, polar bears and the like, but when Joslin Van Arsdale came upon an image of an iceberg, she was silent. She pondered the image for a good long while and finally looked up at me and asked, "Do you have any more of these?" She told me she thought a series of just icebergs would be interesting to see. I took her advice and compiled twenty-five of my best iceberg images. I entered those images into a competition with no expectation of winning the top prize of having my work published as a book. I entered for the exposure. This particular competition sent out the entries to over 250 industry professionals—galleries, museums, magazines, publishers, and editors. Then my phone began to ring. The curator for the Museum at the University of Michigan called to ask about size and price information of my work. Other galleries began to contact me, asking if they might represent me and show my work. And then, amazingly, the curator for the Museum at the National Academy of Sciences contacted me and asked to fly out and see my work.

My friends had told me that if I wanted to "make it" in the photography world, I would have to work my way up the ladder. "Start small," they said. I was told that I should see if any of the local cafes might be interested in showing the work. Then, they suggested, after I had had a few cafe shows, I might then approach some small local galleries. I was adamant when I told them, "I'm sorry but I do not see my work in cafes or in small galleries." They told me, "Then you won't get very far."

I had a vision of my work hanging in a grand space with white marble floors. I could not explain to them that the vision was clear—it was that vision I would hold to. When the curator from the National Academy of Sciences arrived at my Berkeley studio, I was more than a little nervous. I wasn't sure what he wanted or why he had traveled so far to meet me and see this work. We looked through the images and talked for a while about the work and how I had come to make it. Then, he told me he wanted to offer me a solo show at the museum in our nation's capitol. I felt I had to tell him, "But I have never exhibited or shown my work anywhere, not even in a cafe." He told me the work was important and needed to be seen. He wanted to be the one to show it first.

Months later, after the prints were shipped to Washington, D.C., it was time for the exhibition opening reception. I felt such a deep satisfaction to discover my work was in this historic building—not only was it a very grand space, it had white marble floors!

After such an auspicious beginning to my career, great things continued to happen. I had exhibitions of my work all around the globe. My images and parts of my story were published in magazines in many countries. I was asked to speak more and more around the world, and everywhere my work and words were shared, people reached out to let me know how much they appreciated what I was doing. I began to realize that the story I told was as important as the images. I had not realized how singular my point of view was, or how relevant it was for these times.

In 2011 I became a TED fellow, which launched me onto a global stage alongside other positive thinkers. If there is one positive thinker who continues to inspire me, it is Martin Luther King Jr. When he spoke he inspired others to action. He never spoke only of how oppressed or subjugated his people were. He led others to take the first difficult steps towards a new future. I understand that without positive inspiration, people might be left feeling too fearful to move forward. TEDsters are interested in more than just talking about change; they want to be and make that change. I realized as a TED fellow that I had no interest in spreading fear and would follow instead a positive approach in addressing climate change.

Each one of us is an earthling, and we share this planet with many thousands of other kinds of life (also all earthlings), the vast majority of which are in some way related to us, buds and branches on the tree of life. I thought that the time had come to spread the stories that I had been raised hearing, to freely share knowledge that my family had shared with me, to offer those stories that redefine our creaky understanding of the role of humanity. I needed to tell those stories that remind us of how beautiful, how precious and fragile this planet is. We who live on this planet need to step up, discover and abide by those rules that honor this planet as an interconnected ecosystem. Earth is not a playground for humans. If one species falls, we all fall.

Then one day, I came across an image that defined what this work meant to me personally. It was a photograph of a young Athabascan girl holding a sign at a protest of native Canadian peoples of tar sands on their lands. The sign between her arms that simply said, "BE A GOOD ANCESTOR."

It was as if she were speaking directly to me. In that one image, a child was asking me to think of the future generations. I realized that I was asking those who look at my images to do the same.

Tabular Iceberg Reflected

Cape Adare, Antarctica, December 2006

This was a bittersweet morning near Cape Adare. We were planning
to head north back to Hobart, Tasmania, in a few hours, leaving the
Antarctic behind us. The fog and snow made for a melancholy mood,
and all alone sat this birthday cake iceberg, silent and still.

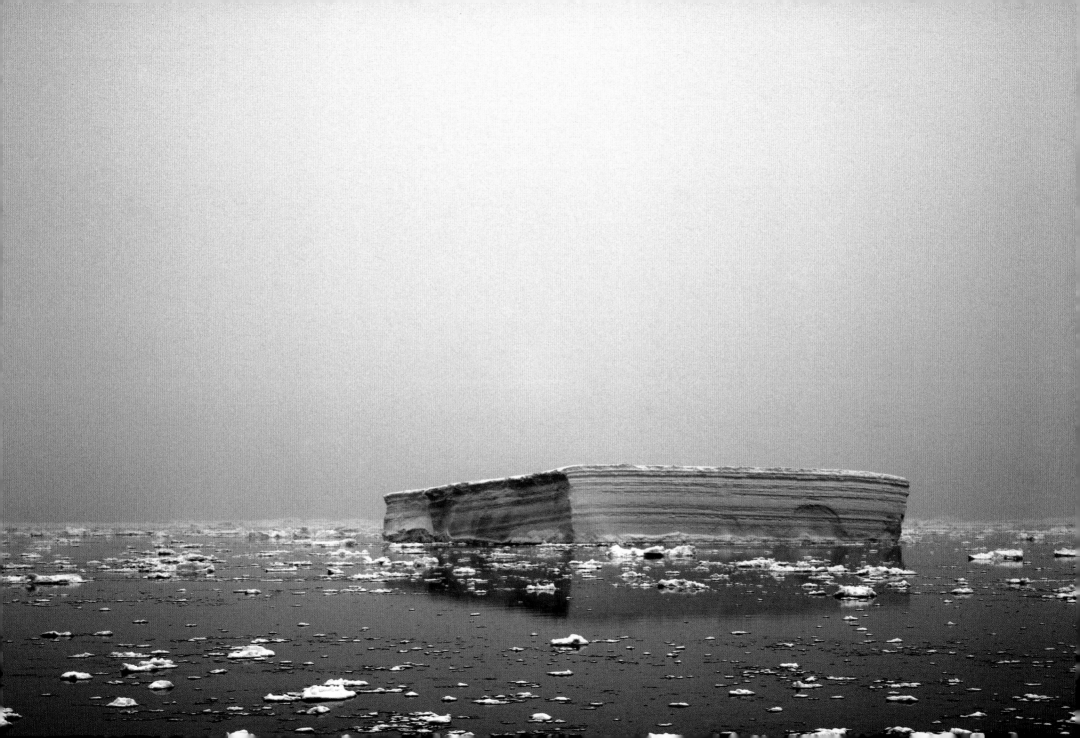

Walrus vs. Hut

Poolepynten, Svalbard, July 2008

They were easy to smell, even from far away. We were restricted from
getting any closer than fifty feet though we stayed even a bit further
so as not to disturb them. It was difficult to really judge their size, until
I saw four large Norwegian men (coast guard officers) enter the hut,
then minutes later I watched as a walrus suddenly made the hut look
tiny. I understood then just how massive this creature was.

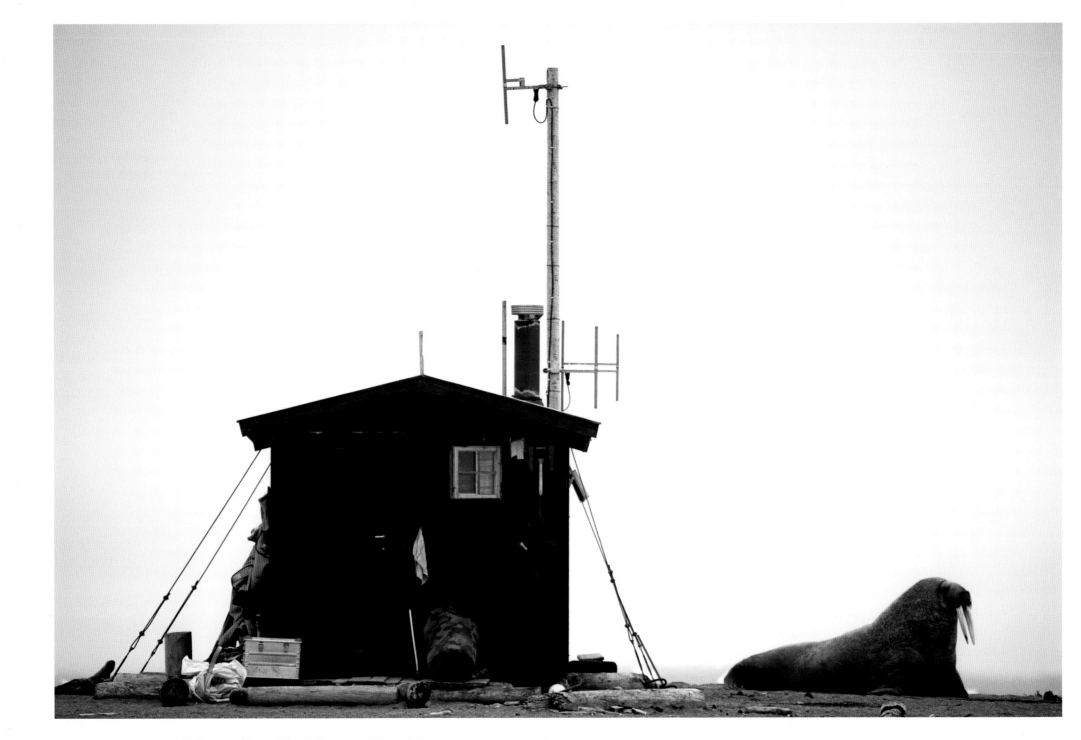

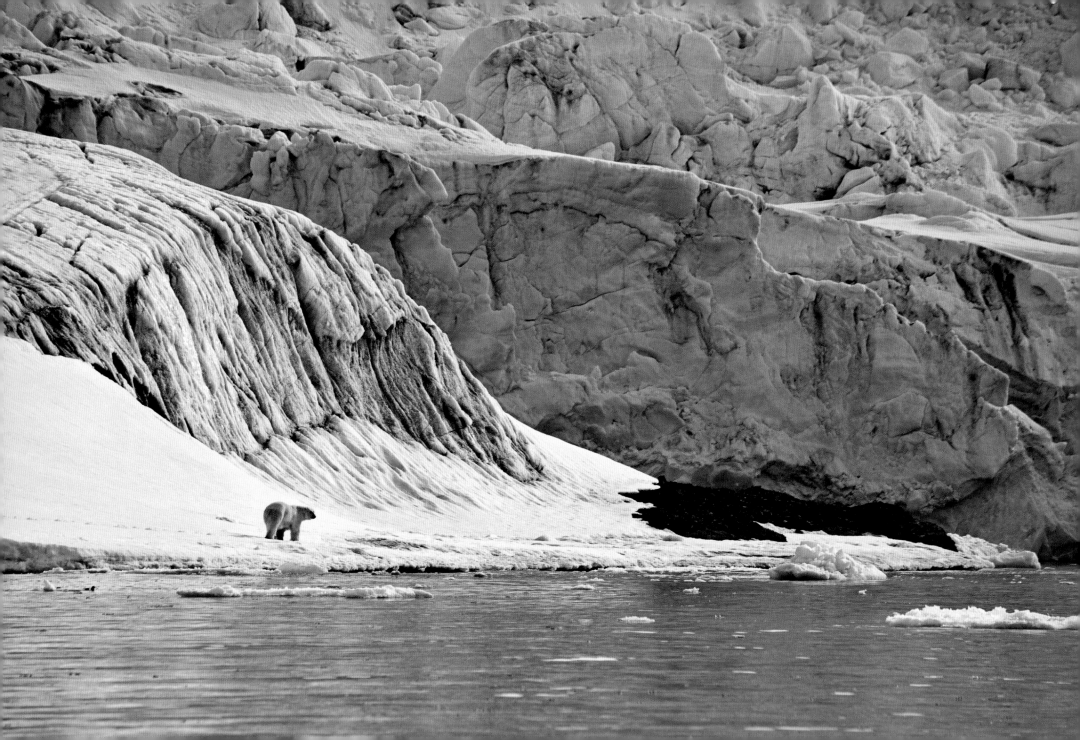

Polar Bear by the Glacier

Svalbard, June 2009

With less and less sea ice in summer months, polar bears head to glaciers to find places to cool off. There is also always a chance that there may be some seals at the front of the glacier if there is any sea ice remaining.

Stranded Polar Bear, Lower Savage Islands

Canadian Arctic, August 2008

I had no idea what adept rock climbers polar bears are. I watched
as this bear climbed up and up to perch on this rock. On these islands
the bears have nothing to do but wait. Sleep and wait and look for
bird nests or anything else (including polar bear cubs) that they might
be able to eat.

overleaf

Arctic Tern

Poolepynten, Svalbard, June 2010

She is one of the most amazing creatures I know. She is a marathon
runner of birds. She flies from the Arctic to the Antarctic every year.
And this year she has laid a single egg on the sand somewhere in front
of me. Because her egg is so well camouflaged, I am in danger of
stepping on it and she does not like that. She flies up and swoops low,
cheeping and pecking at my hat (I hold it high so as to distract her from
my head). I back away slowly and only when she has deemed her egg
is a safe enough distance away from my clumsy foot does she delicately
land in silence to resituate herself atop her egg.

Siberian Drifters

Svalbard, July 2008

Taking photos of walruses hauled out on a beach can be like
photographing a bunch of potatoes. It takes patience and
preparedness; they always eventually move, shift, or scratch. If you
are patient, you might even get a face-to-face gaze like this one.

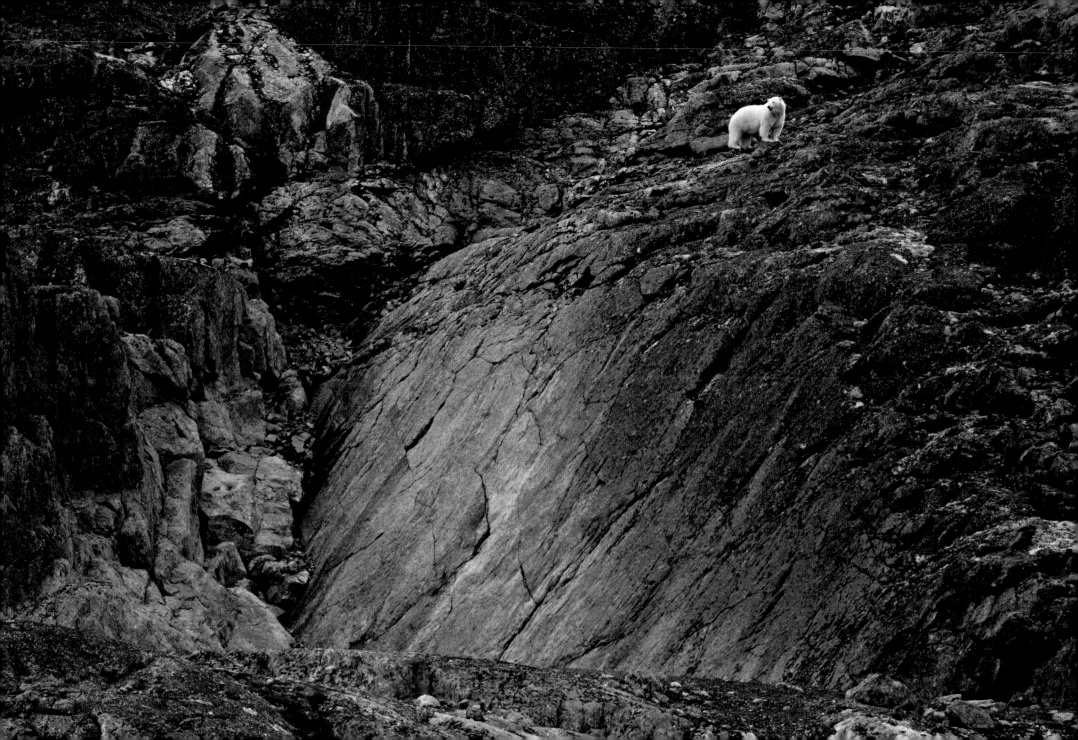

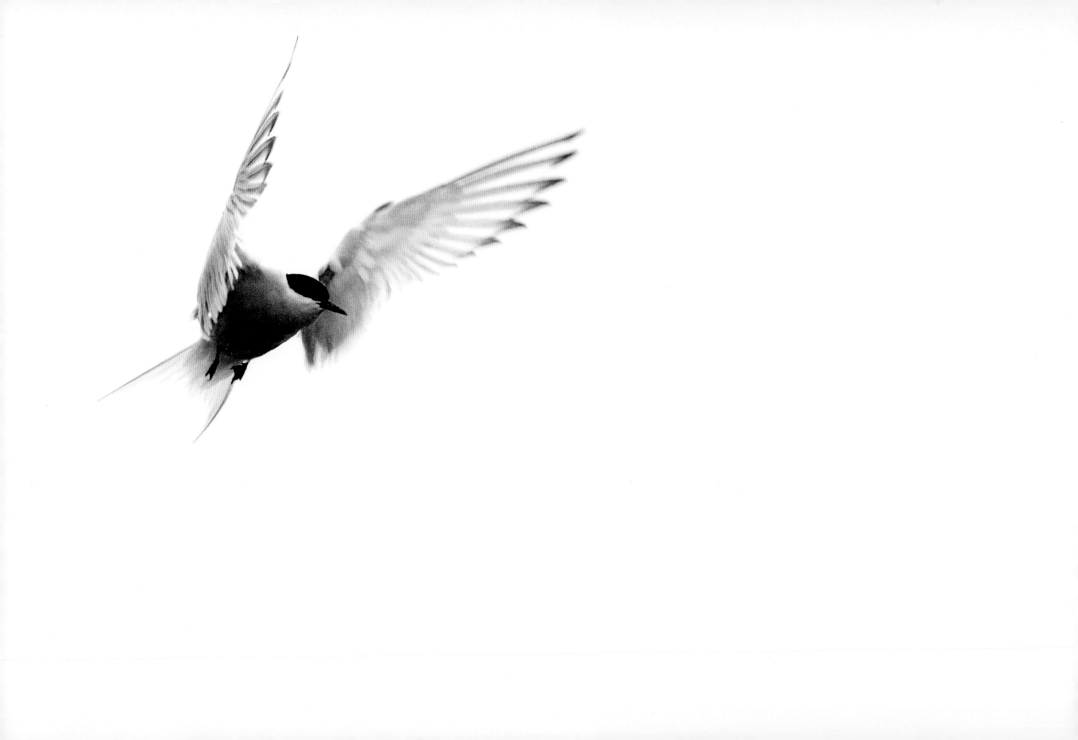

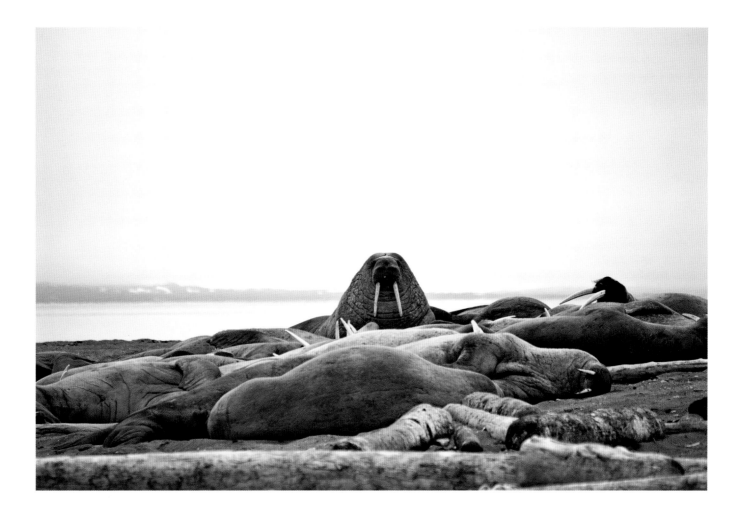

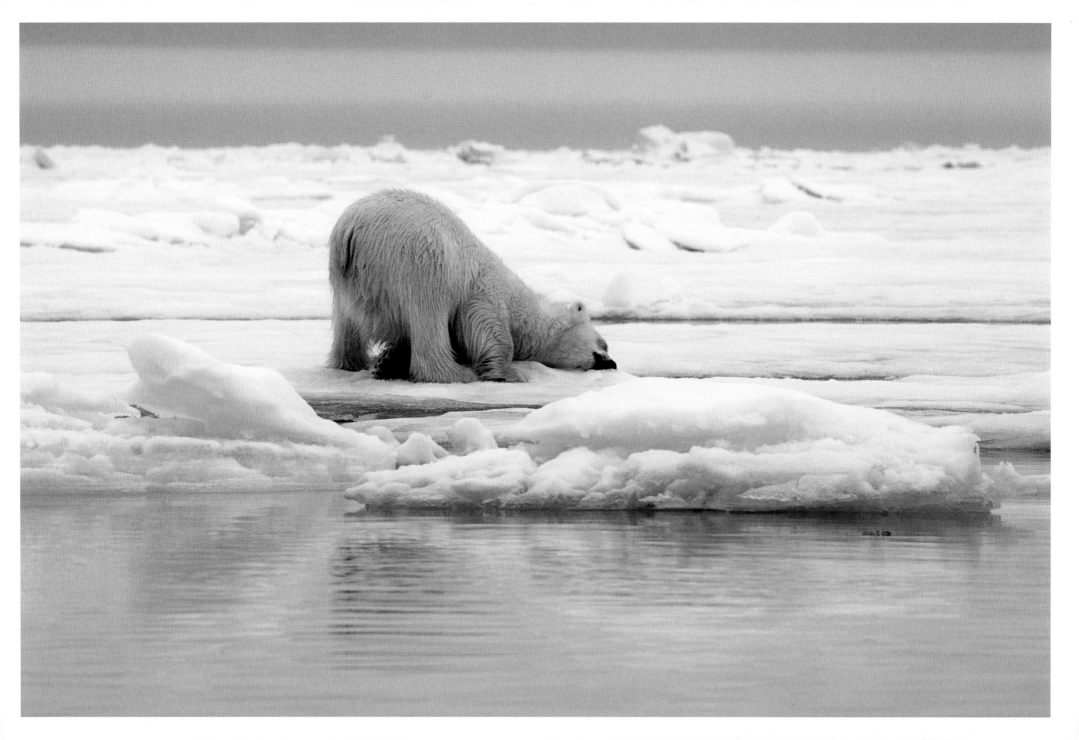

Cleaning Her Fur
Svalbard, July 2008

This young female polar bear was cleaning the salt from her fur by rubbing against the clean snow and ice. Polar bears have skin that is completely black under their dense hollow-shaft fur. The nature of the fur draws heat toward their dark skin and efficiently keeps the bear warm in the extreme cold.

I was able to make this image as I sat in a small boat. We were only about thirty feet from her and we may have been the first humans she had ever seen. She was very curious and remained close to the edge of the ice floe as her mother watched from some distance away. This was one of my favorite polar bear encounters in Svalbard.

overleaf

Polar Bear Invades Bird Colony II
Svalbard, June 2010

We watched from our ship as this young bear swam over five miles, following his nose to this small islet with a thirty-foot-high ledge of cliffs. There were birds nesting on the top of those craggy rocks. And a hungry bear is a hungry bear. These glaucous gulls were on high alert and very leery of the bear.

Polar Bear on Glacier
Svalbard, June 2009

This polar bear was making a perilous journey up and across a glacier. The polar bear's incredible sense of smell will guide away and around treacherous crevasses. After his journey, I was relieved to see him down by the shore on the other side.

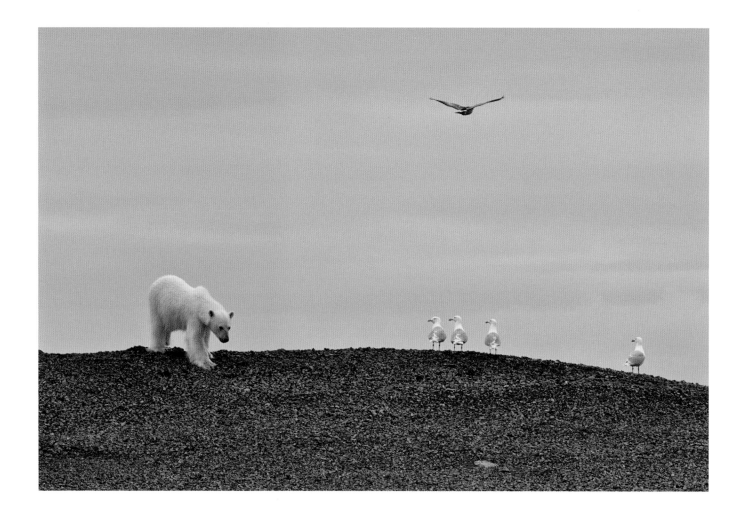

Polar Bear Invades Bird Colony IV

Svalbard, June 2010

In less than two hours, I watched this bear travel across the rocks from nest to nest, with gulls and eider ducks scrambling to safety in the air. They had no choice but to abandon their eggs and helpless chicks to the hunger of the bear. He left no nest unmolested. It was in this scene I began to connect the dots of how what happens at the poles directly affects us in our temperate zones. These birds fly thousands of miles to lay their eggs. In just a short amount of time a generation was wiped out. No ice, no seals, hungry bear eats birds, no birds to eat pests on European farms....

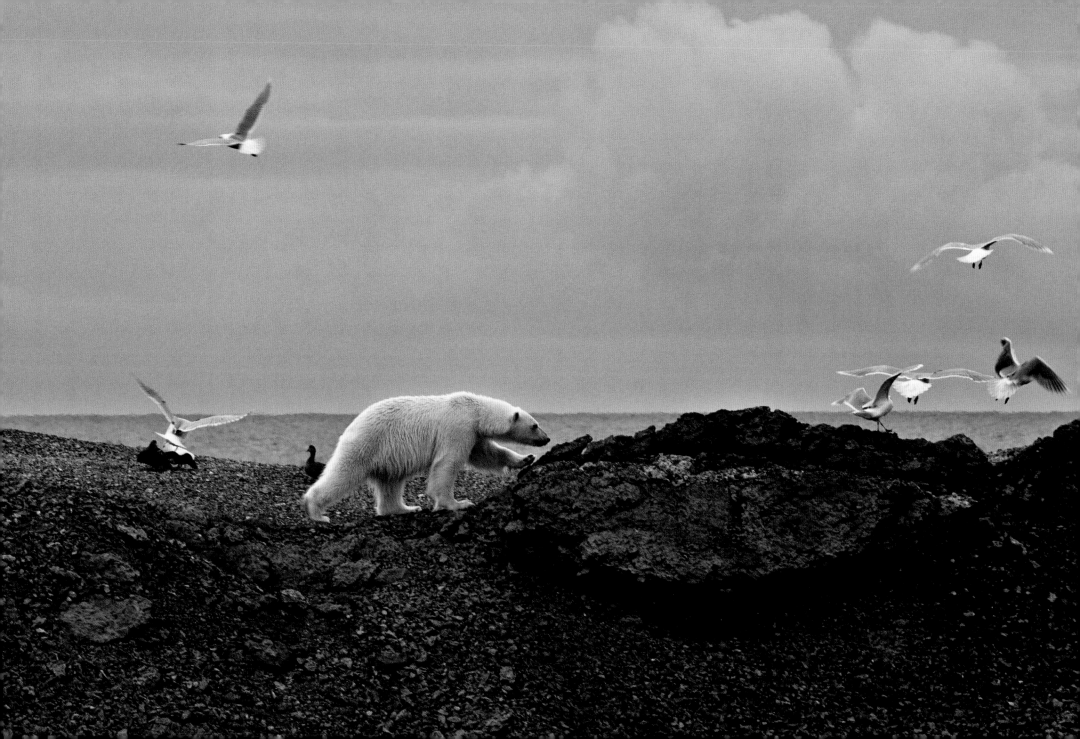

Arctic Tern, Poolepynten

Svalbard, June 2010

overleaf

Looking for a Future, Lower Savage Islands

Canadian Arctic, August 2008

We counted over thirty-two polar bears on the island. There was no snow or ice and open sea all around. Here the bears had a long wait for the ice to return. It would mean death for some of them and possibly even cannibalism.

On the Edge

Svalbard, June 2010

She looked at us as we sat in our zodiac. The passengers were eating chocolate covered strawberries and sipping champagne from long-stemmed glasses. I wondered what she thought as she looked at us. Her mother was about a thousand feet away and raised her head every now and then to get a good whiff of her cub. She was almost two years old, almost ready to leave her mother and go off on her own. I will probably never see her again. I wished her luck as I took this photo.

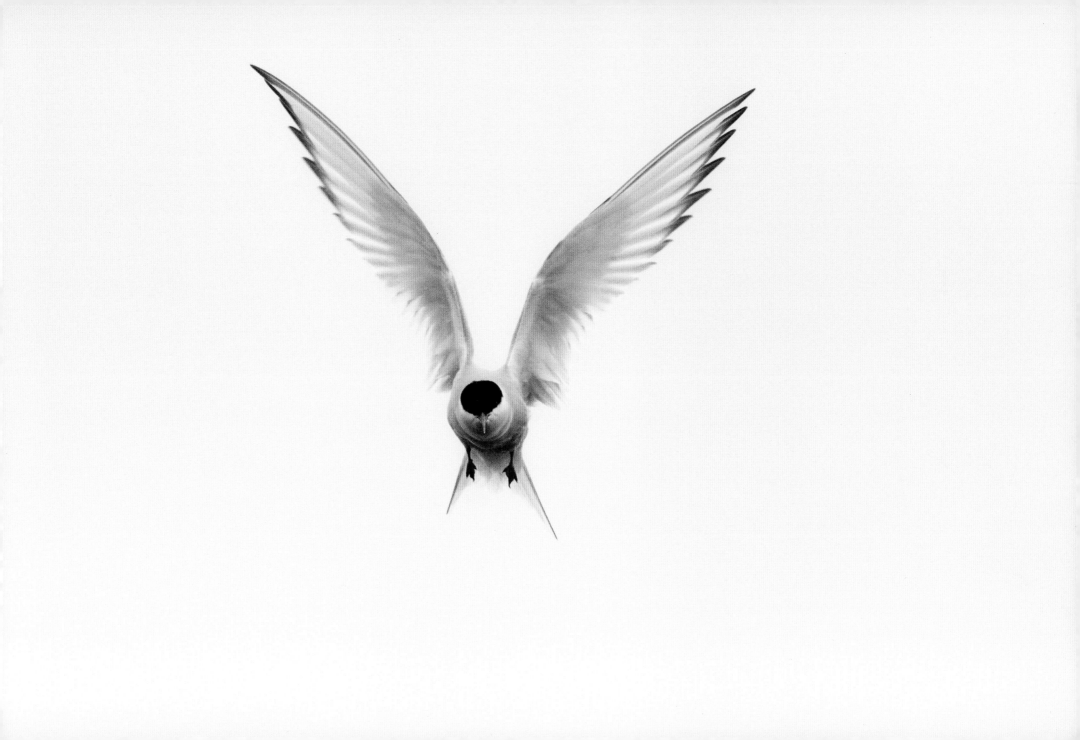

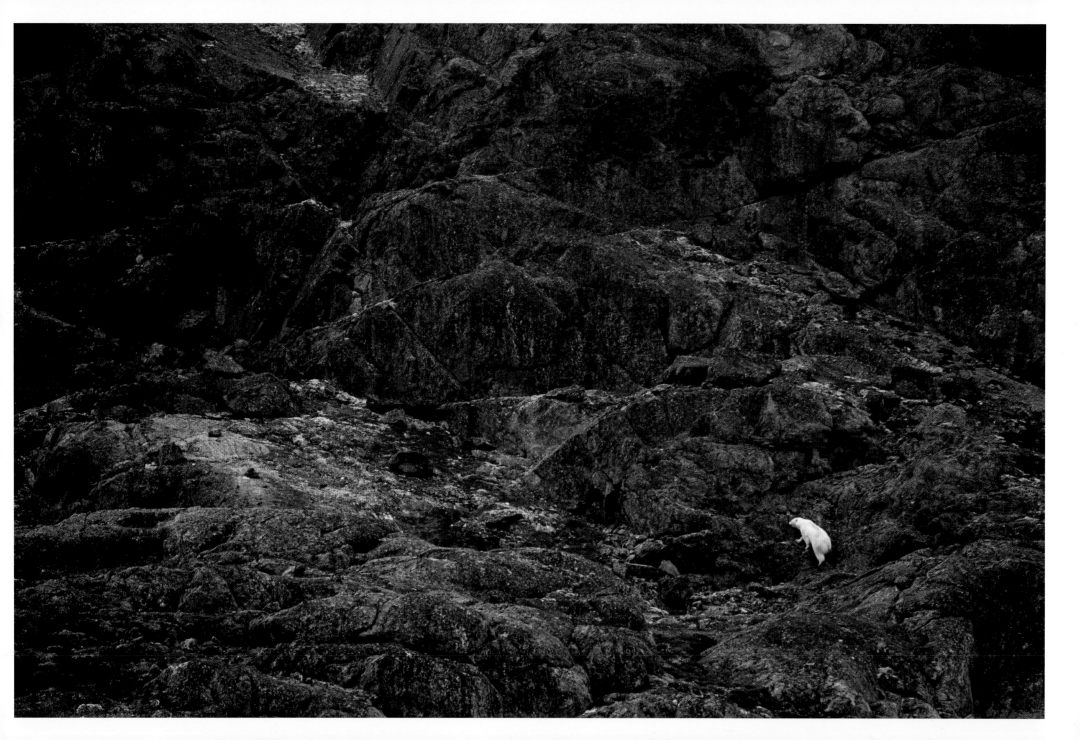

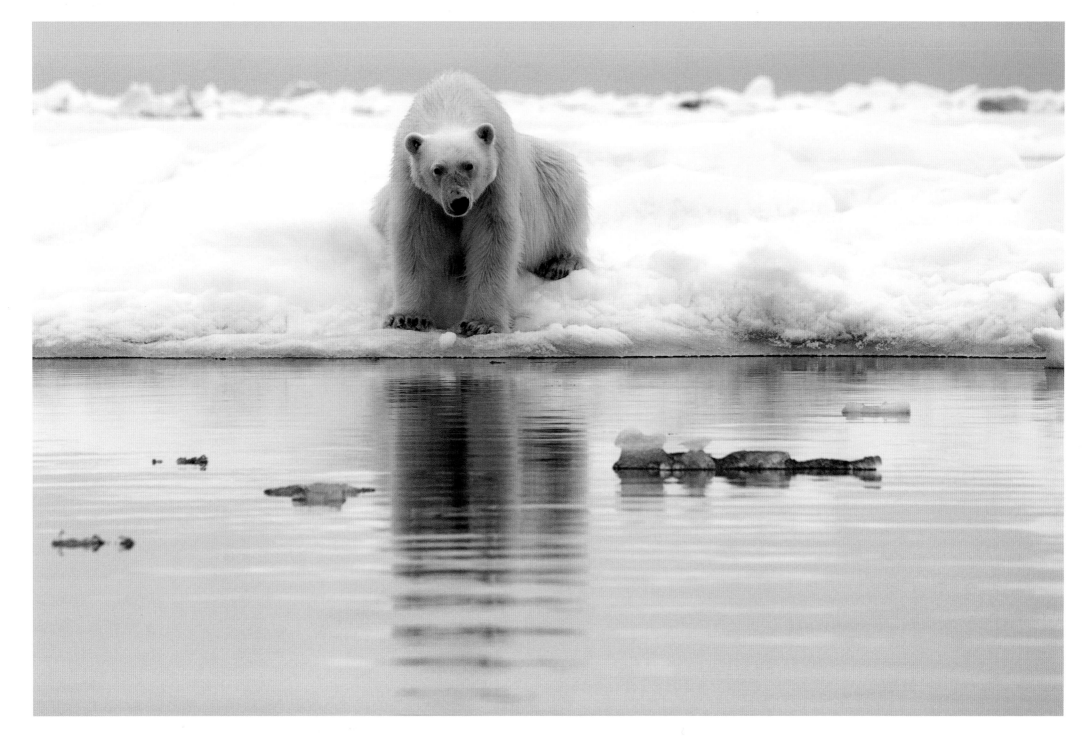

VII

Giving up my seat on that oversold Alaska Airlines flight in 1999 was indeed one of the greatest life-changing events in my still expanding life. Using that free ticket to travel to a place I never thought I needed (or wanted) to visit set in motion a series of remarkable events. The richness and beauty of the life I now live is something I never could have thought possible.

I am writing this on the last day of the year. The time I have had to reflect has granted me some wisdom. As we move forward further into the twenty-first century, we are all aware that things must change. Things always change. The choices we make today will necessarily have far-reaching effects. As we consider what we must keep and what must fundamentally change, I hope that by reading a small bit of my own personal story you might come to know what is true for you, for me, for all of us.

We are all earthlings. The earth does not belong to us, we belong to it. Knowing this, how can we continue to sit and do nothing? How can we as citizens of earth look to others to pick up the trash, clean the water and the air and our soil? I have been asking myself for a long while now, "Does it have to be me?" I know in my heart that the answer is yes. It has to be me and you and you and you. Each one of us has unique abilities. Each one of us has something that we do like no one else on the planet. Each of us is absolutely necessary. We need each other. *I need you*. We need every single species of plant and animal. We define each other. Without others, we would not know ourselves.

The change has already begun. The pace seems slow, only because I am impatient to see how grand and glorious we actually will be. Each one of us is several billion years in the making yet we are of this moment. The collective experience stored within our cells makes us the right people for the job. I see more and more people creating solutions, asking questions, or shining light on areas that need to be exposed. The doers, the makers, the thinkers, the visionaries, all are looking for a way forward that will make us proud to call ourselves not only human but of this earth. We are earthlings.

Change is coming. Somehow we think that change means loss or sacrifice, but change has a greater range. It can be scary or encouraging, troubling or rewarding, and I prefer to think of the coming change as encouraging and rewarding. It is becoming easier and easier to imagine a human world that defines itself not by how much stuff we have, how much bling or status, but by how well we can live in harmony within our environment, how we treat other species with respect instead of subjugation, acknowledging that the earth is *not* a resource for humans to exploit. This planet is not ours to use then discard. Let us seek to understand the earth as sacred. The true gift that it is. A verdant blue planet quite capable of offering everything we could ever want, if we care for it with love and careful consideration. Let us define ourselves by that which unites us and not by things that which divides.

"So what can I do?" you ask. "I am just one individual. How can I possibly help to effect the positive change that is needed when that necessary change seems overwhelming, if not impossible?" I too have felt this way, dismayed by what I see, depressed by the sheer weight of the difficulties we face. I asked myself these questions, but I discovered that what I do *does* make a difference.

I had no idea that the images I make would find their way around the world, touching people in a very personal way. It doesn't seem like much, doesn't feel like that big of a deal. Yet every time I receive an email from someone telling me that they will never see ice the same way after seeing my portraits of the polar regions is important. Each time others let me know my work has touched them in some way, I know the work has been worth the effort. Worth the costs I pay. I was an apathetic earthling, just hoping I could do my thing and make no trouble, walk quietly through my life, and call that ok. I am sure many of us feel this way, but, in the end, it is necessary to step up for the benefit of future generations and for those with whom we share the earth in the here and now. We must step forward as a son, a daughter, a mother, a sister, a friend, a neighbor. We owe it to each other. We owe it to *all* our fellow

earthlings. Each breath we take comes so easily, so effortlessly, but that air is not inviolable. Its clarity and its purity are delicate, the breathing fragile. It is our duty as inhabitants of this planet to honor and revere the breath of life, if we want human life to continue on this planet.

What is your special gift? What is it you do that brings you great joy?

Inevitably what makes you happy serves others. We all live in service to one another and when we acknowledge that, good things happen. The best thing you can do to help the planet is to do what makes you feel good. I know it sounds trite, but when you are happy, feeling fulfilled, you do not consume as much; you do not waste as much. You make better decisions, decisions that benefit others as well as yourself, and those better decisions have a lasting effect.

I have learned along my way that I am the only one who can keep me from whatever it is I want to achieve. Excuses and negative talk—I can't, I won't, I shouldn't—can and will drag you down, stop your growth. If you determine what it is that you really want to do with your life, and then make a list of all the excuses you have for not doing it, you might be able to see how silly those excuses are. Dream the dream of what you would like this world to be and of your life in it. Make another list of what is keeping that dream from fruition, and then analyze how those obstacles might be overcome.

We need you.

We need your vision of what life can be, not just what it is. Creating a peaceful world on this beautiful planet has always been a collective effort. As a mother of a teenage girl, I know and have known since she was an infant that I must lead by example. Positive change happens faster, perhaps, when we cease being children looking to follow the examples set for us, and understand instead that examples of active change must start with the standards to which we hold ourselves and how we confront the difficulties we face as individuals and as members of the greater human family.

My dear friend Paul Hawken once said, "It is not a crisis of climate we face but a crisis of culture." I know that if we would allow ourselves to see our relationship with this planet in an interconnected way and allow that interconnectivity to define what it is to be human, our behavior would inevitably change. Our treatment of our only home, this magnificent planet earth, would change. Change is already happening. Let us make that change positive. I ask you now, how will you answer the call?

Does it have to be you?

Evigheds Fjord, Eternity Glacier

Western Greenland, September 2009

It was named Forever Fjord because it seemed to never end. It is sixty-two miles long. The glacier itself is a shadow of its former glory. You can now see a large prominence of rock, which was covered by the ice not so long ago.

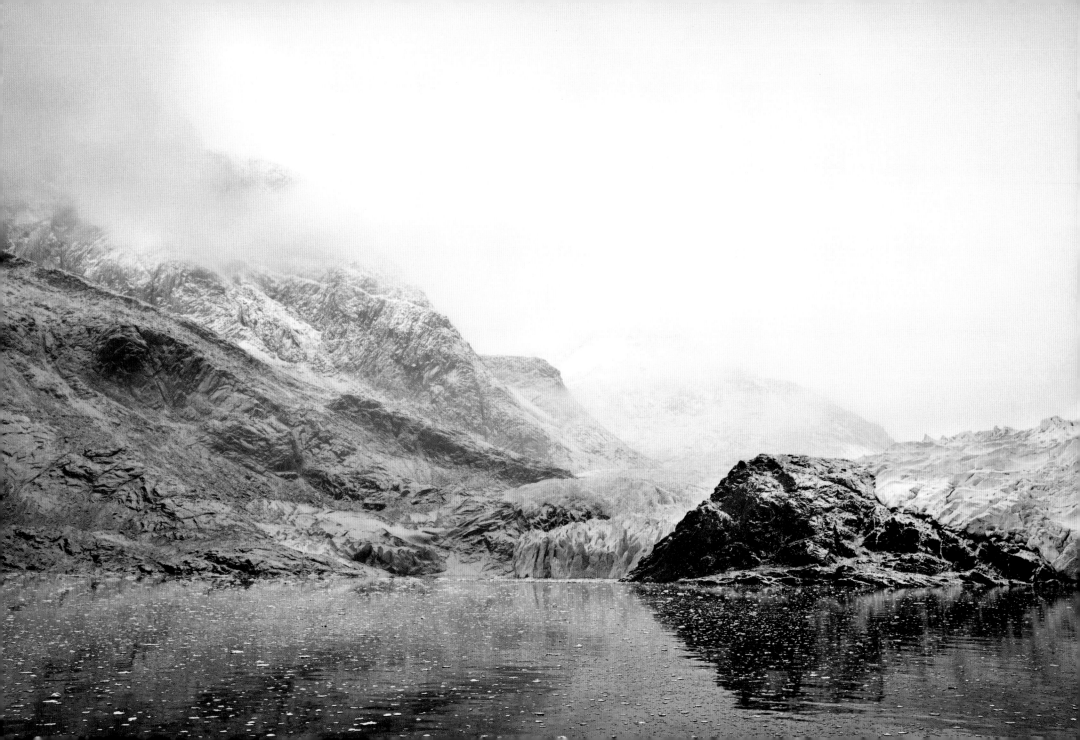

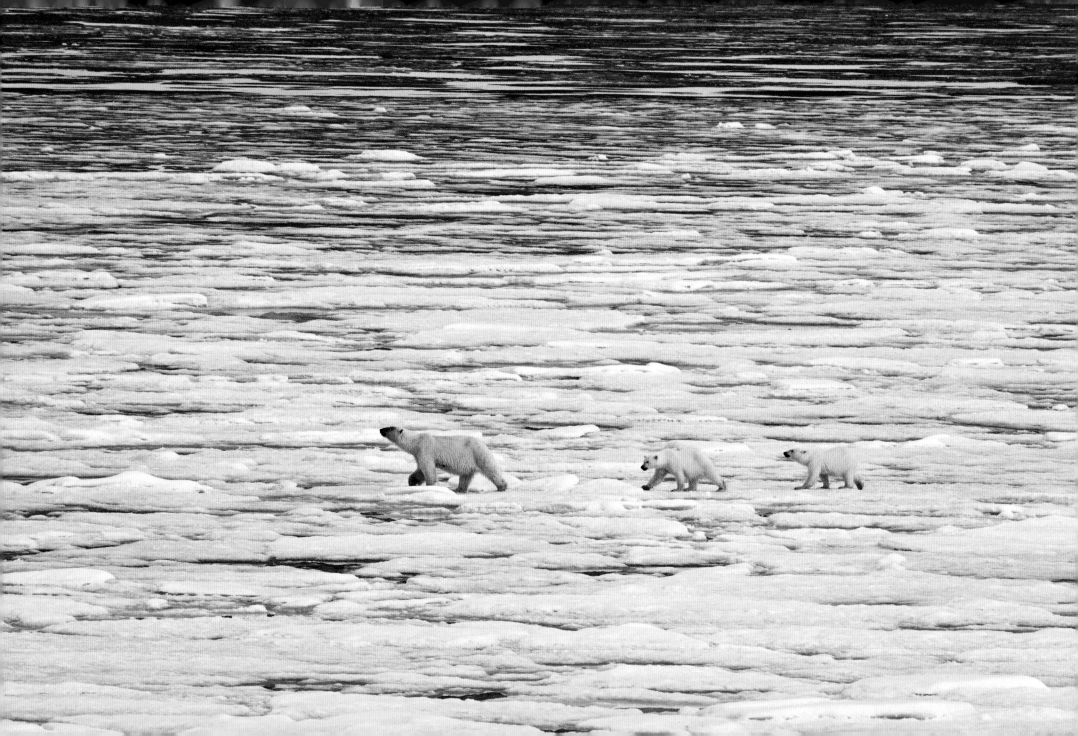

Follow Me

Svalbard, June 2010

It's not easy being a mother of two in the Arctic these days. The mortality rate of cubs is 70 percent. With less sea ice, hunting seals becomes more challenging. Starvation is a reality.

overleaf

The Light Within

Lemaire Channel, Antarctica, December 2007

The Lemaire Channel is famous for its narrowness and its spectacular
peaks that jut straight from the sea. On this evening I witnessed
a strange glow over the peak in the clouds and could not figure out
the mechanism for the occurrence. It remains a mystery.

When There Is Sunshine

Antarctic Peninsula, February 2010

Antarctica is big, but the sky is bigger. The clouds that cover Antarctica
can seem enormous, and when the clouds are lit by the sun magic
can happen. I tend to spend as much time as I can out on deck, always
looking, always ready. On this evening my diligence was rewarded.

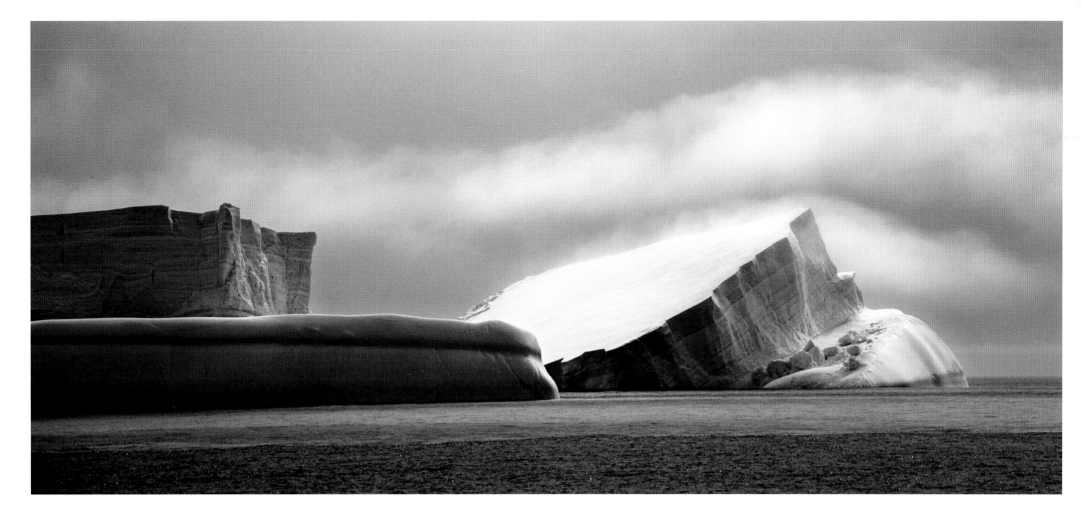

The Cloud Makers Detail

Antarctica Sound, February 2010

In the middle of the Antarctic Sound, like some floating ice stone henge, a mass of giant tabular icebergs produced their own clouds.

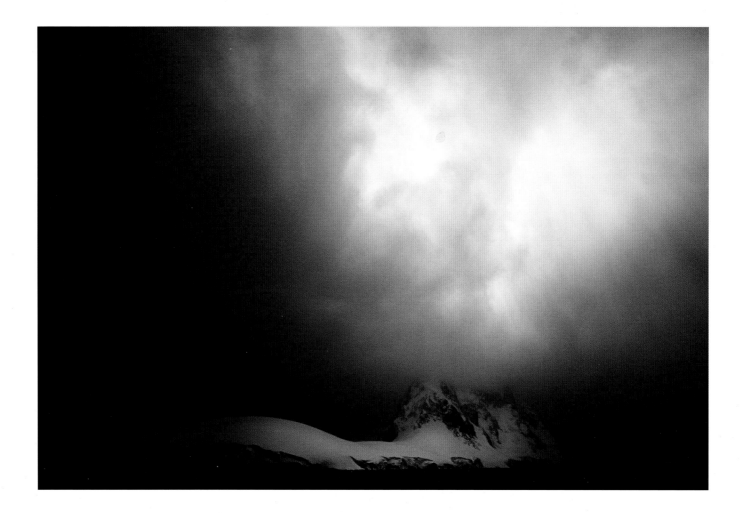

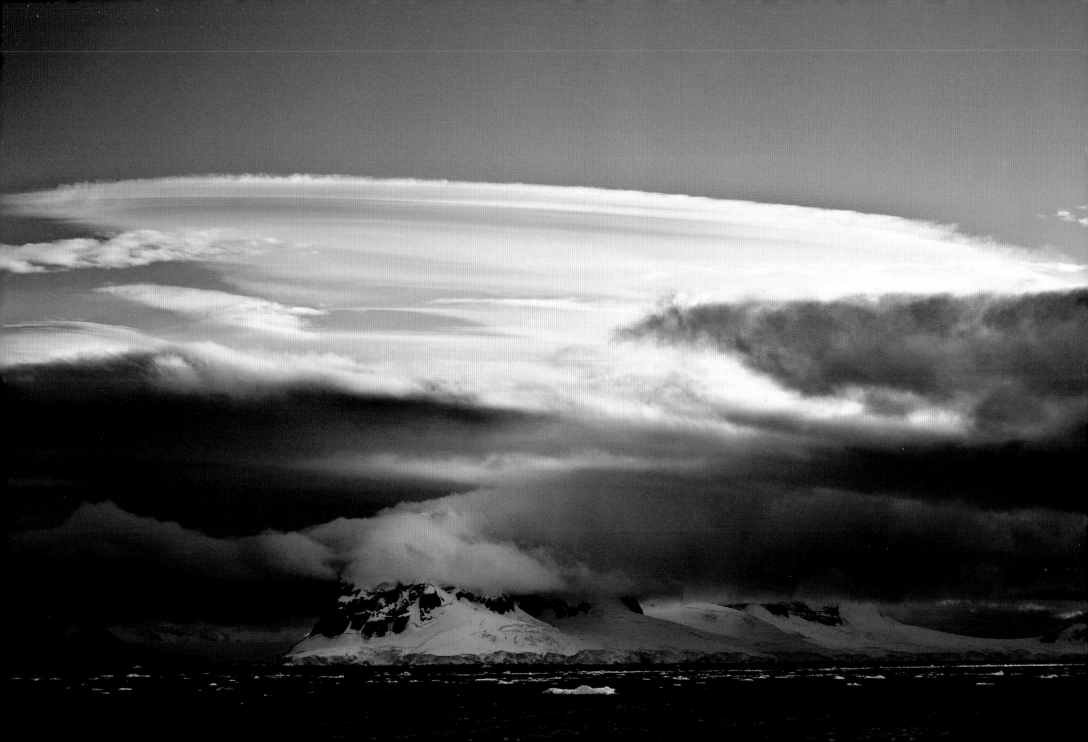

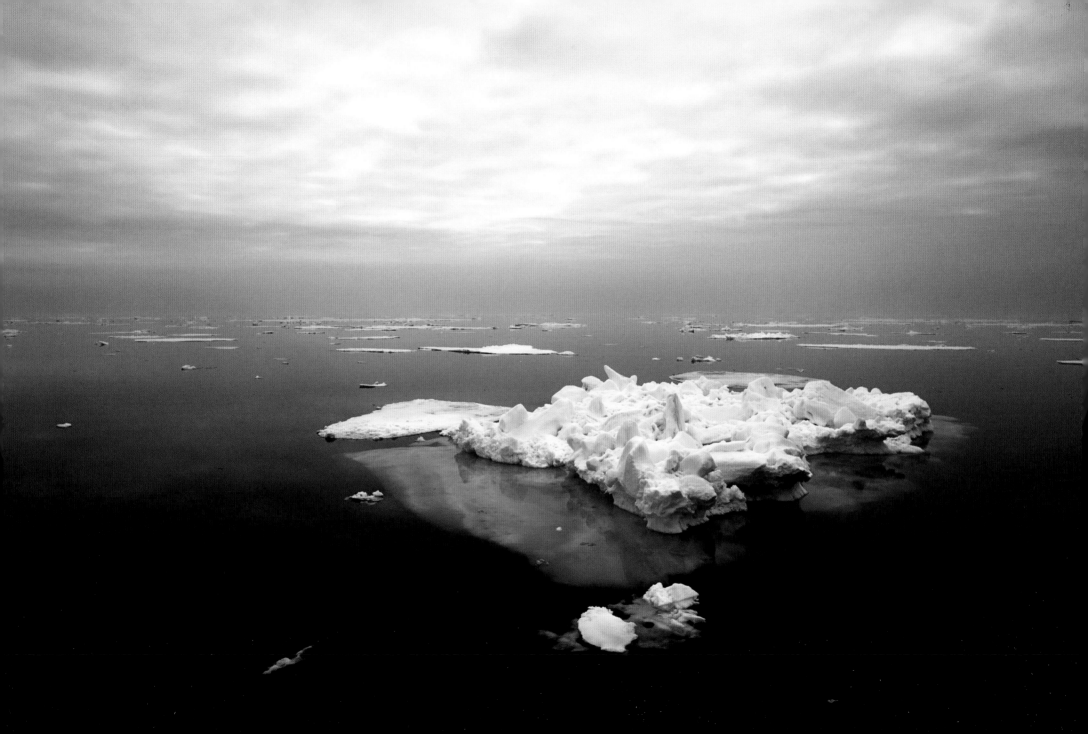

Sea Ice Remnant

Svalbard, July 17, 2008

Less and less multiyear sea ice remains in the warmer temperatures of the Arctic summer. Less sea ice means many things, from the loss of hunting grounds for polar bears, to more heat being absorbed by the growing dark surface of sea. Climate models cannot keep up with the actual rates of melt and the unforeseen side effects of our melting poles.

Floating Icebergs in Drift Ice II

Ross Sea, Antarctica, December 2006

These two massive icebergs were lovely to observe. The sea had
a strong swell and all of the ice was heaving up and down significantly
as if it were breathing. The two bergs drifted toward each other and
seemed as if they might collide. We were some miles away, so I could
not judge very well as to whether they actually did or not.

overleaf

On Top of the World

Nothwestern Greenland, September 2009

We were so far north that I could see Ellesmere Island on the horizon.
There was no wind, no sound except our human noises, our ship
noises, and the occasional pop or crack of sea ice chunks. The sky was
perfectly reflected in the sea. It felt like a hallucination. I wondered
if we had sailed into some other dimension.

Reflections

Baffin Bay, Greenland, September 2009

With Ellesmere in the distance the dream of high Arctic light plays
tricks on the mind. It is perfectly still. I am left without words that
there is so little ice so far north.

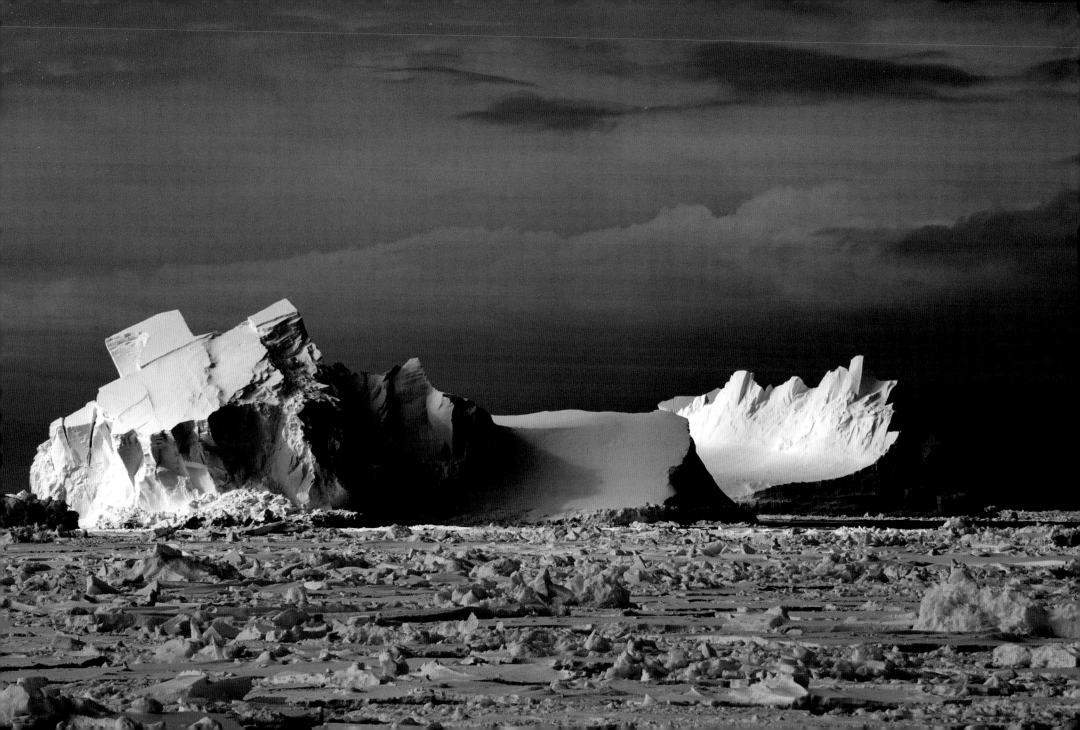

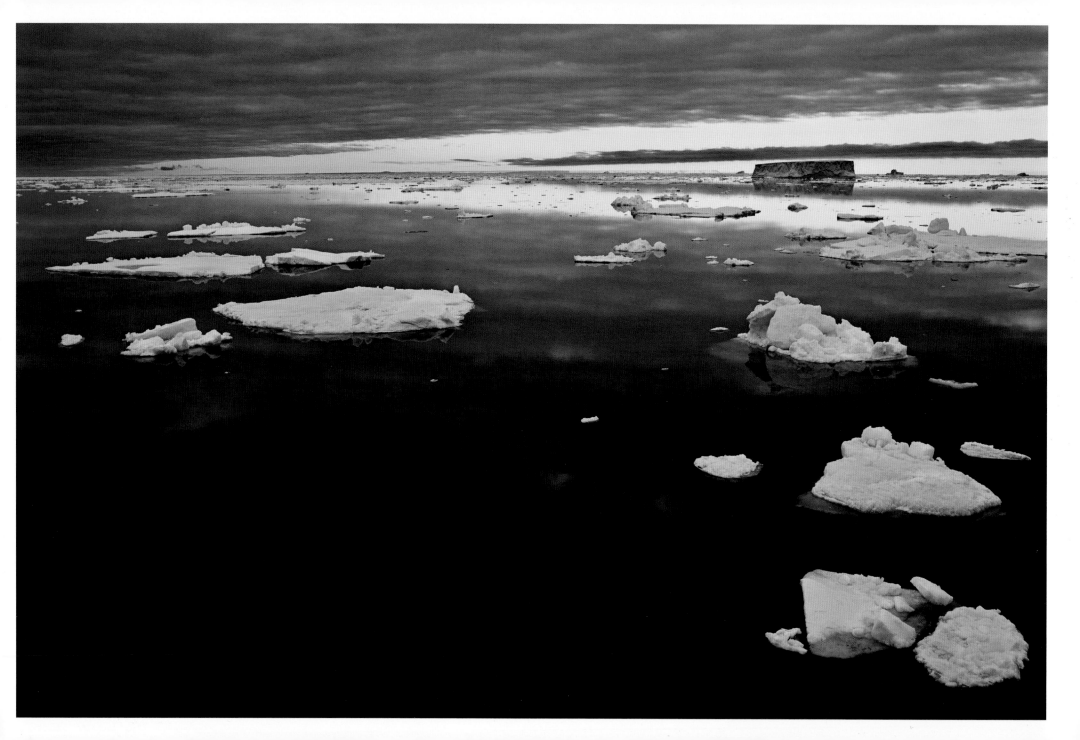

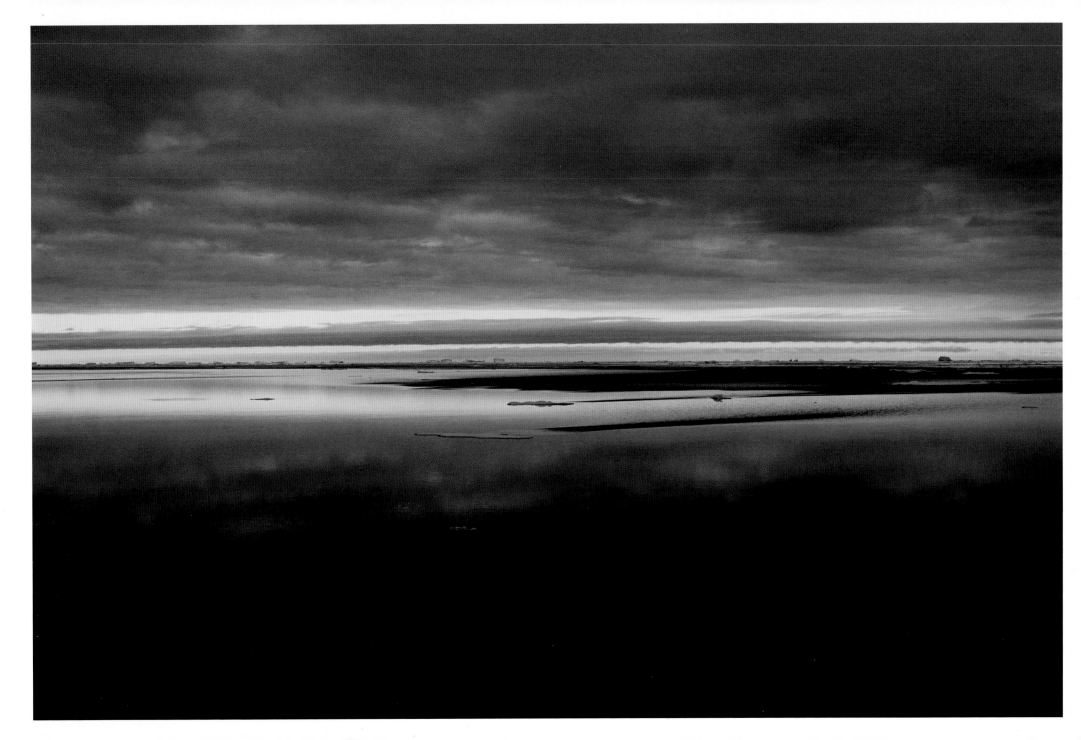

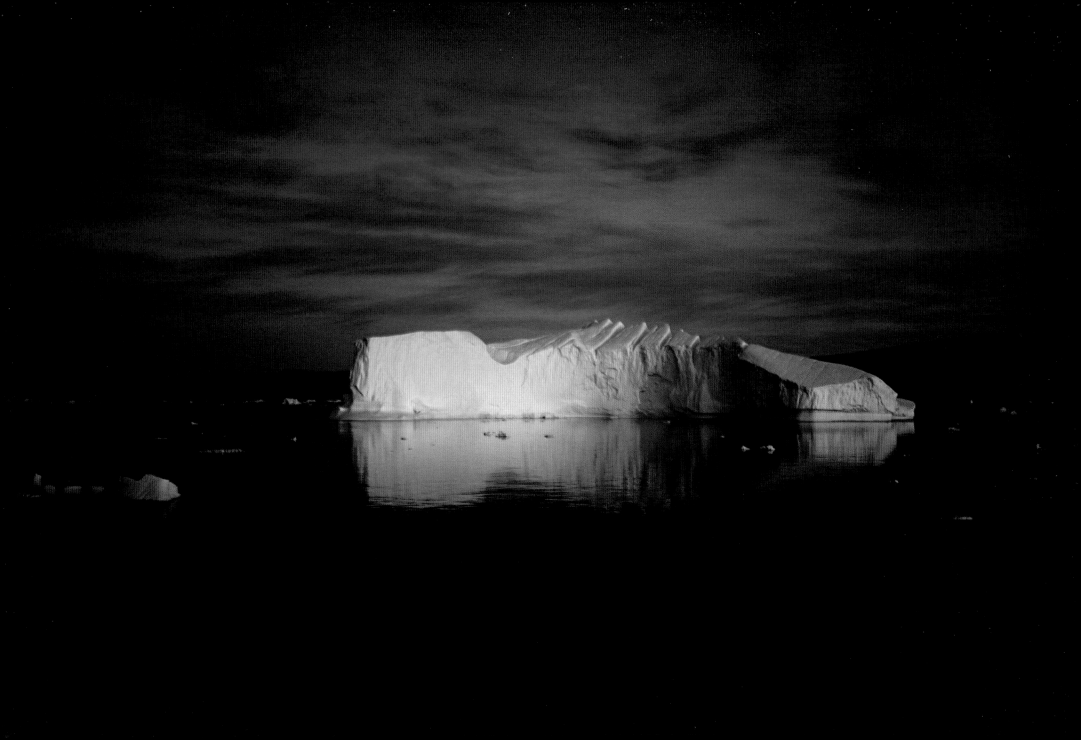

Iceberg at Sunset

Western Greenland, August 2009

You can imagine that sailing through iceberg–laden waters on a ship as darkness descends can be a very serious business. There are large spotlights on the bow of the ship and there are crew members dedicated to the watch. It's not the big icebergs that you need to look out for; it's the small and clear ones. They're sometimes called "black growlers" because you can't see them in the water. Growlers are old and dense—all that's left of a once—massive iceberg. They float low at the surface like an invisible can opener waiting for your ship to pass by.

Thinking of Turner II

Antarctic Sound, Antarctica, February 2010

It is not often I would experience darkness in Antarctica, as I mostly was there in high summer, which meant twenty-four-hour daylight. In late February, as we headed north through the Antarctic Sound, we were fortunate to experience an Antarctic sunset. The colors were epic. The sun set in front of us and was rising behind us at the same time. Truly an experience I will never forget.

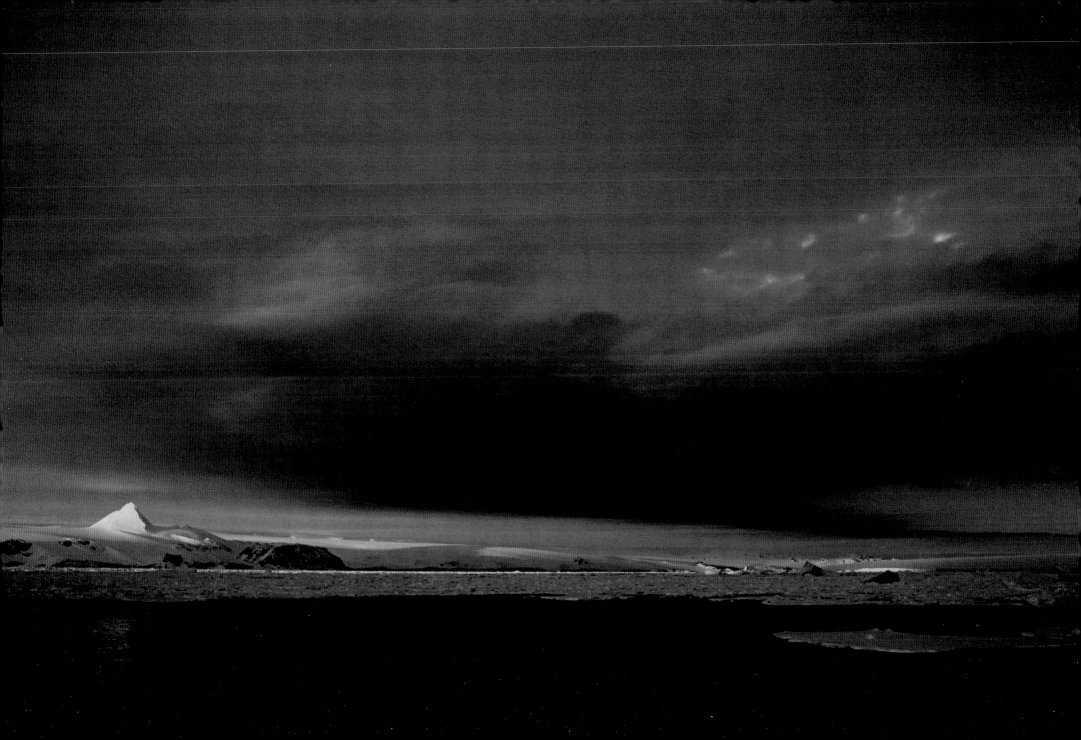

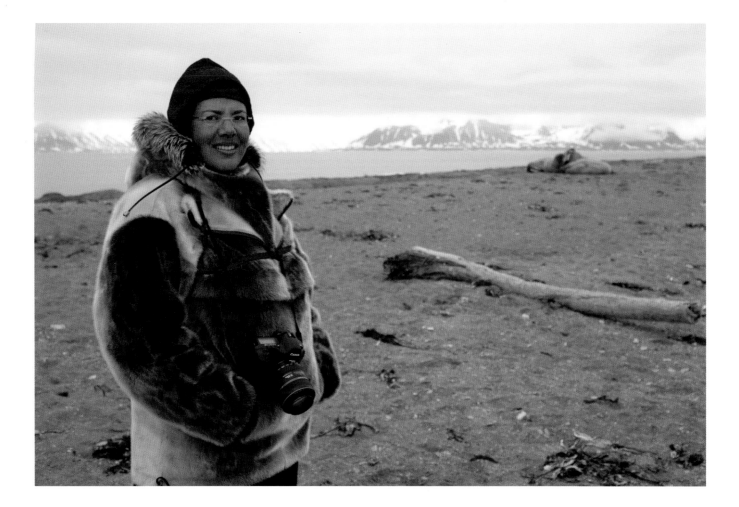

Deep gratitude to Tia, the TED Fellows program, the Stanford Knight Fellows class of 2014, Hurtigruten, Steve McCurry, Theme Media, the Ice, and all my relations.

Published by
Princeton Architectural Press
37 East Seventh Street, New York, New York 10003

Visit our website at www.papress.com

Editors: Jennifer Lippert, Jay Sacher
Designer: Jan Haux
Design assistance: Mia Johnson, Paul Wagner

Special thanks to: Meredith Baber, Sara Bader, Nicola Bednarek Brower, Janet Behning, Megan Carey, Carina Cha, Andrea Chlad, Barbara Darko, Ally Dawes, Benjamin English, Russell Fernandez, Will Foster, Jan Cigliano Hartman, Diane Levinson, Emily Malinowski, Katharine Myers, Jaime Nelson, Rob Shaeffer, Marielle Suba, Kaymar Thomas, Joseph Weston, and Janet Wong of Princeton Architectural Press —Kevin C. Lippert, publisher

Library of Congress Cataloging-in-Publication Data
Seaman, Camille, 1969–
Melting away : images of the Arctic and Antarctic / Camille Seaman.
 pages cm
ISBN 978-1-61689-260-9 (alk. paper)
1. Polar regions—Pictorial works. 2. Icebergs—Polar regions—Pictorial works.
3. Natural history—Polar regions—Pictorial works. 4. Animals—Polar regions—Pictorial works.
5. Climatic changes—Environmental aspects—Polar regions—Pictorial works.
6. Seaman, Camille, 1969- l—Travel—Polar regions. I. Title.
G593.S43 2015
910.911—DC23
 2014018830